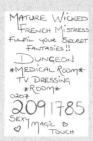
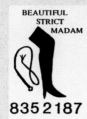

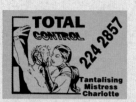

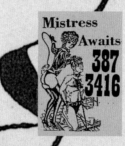
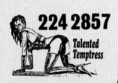
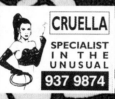
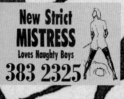

LONDON'S ILLICIT ADVERTISING ART

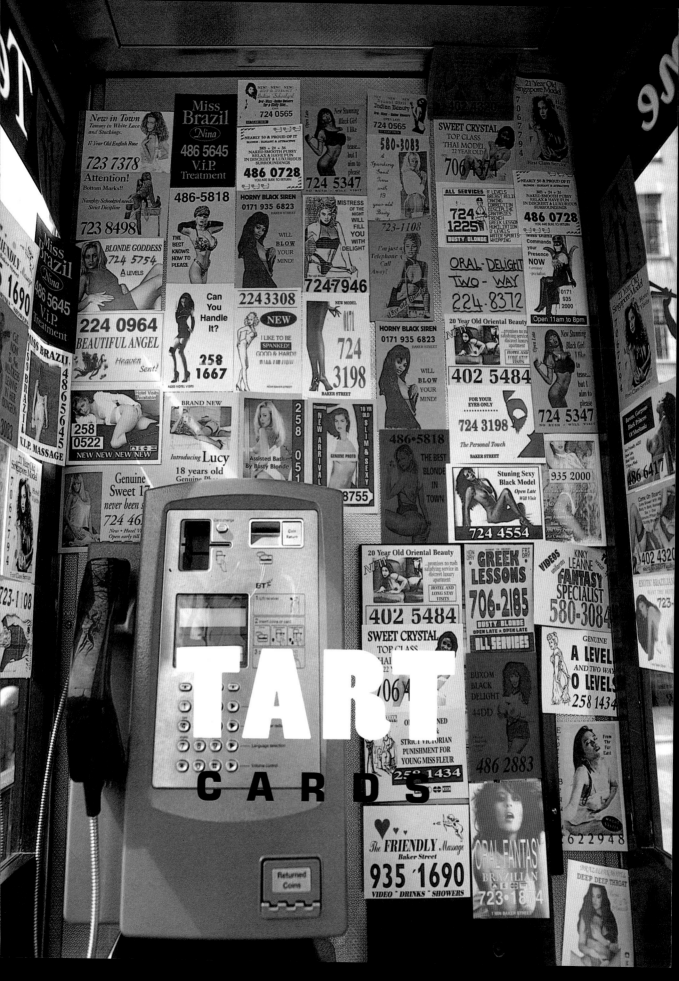

TART

CARDS

CAROLINE ARCHER

MARK BATTY PUBLISHER

Paula Kelly: Design (paulakellydesign@mindspring.com)

Printed and bound in England by Butler and Tanner.
First Edition

This edition © 2003
Mark Batty, Publisher, LLC
6050 Boulevard East, Suite 2H
West New York, NJ 07093 USA
www.MarkBattyPublisher.com
ISBN: 0-9724240-4-0

Library of Congress Cataloging-in-Publication Data
Archer, Caroline, 1961-
Tart cards: London's illicit advertising art / Caroline Archer ; photography
by Rob Clayton.– 1st ed.
p. cm.
Includes bibliographical references.
ISBN 0-9724240-4-0 (alk. paper)
1. Advertising – Sex oriented businesses – England – London.
2. Advertising cards – England – London. I. Title.
HF6161.S46A73 2003
659.1'9306742'09421– dc21
2003006978

ACKNOWLEDGEMENTS

The St Bride Printing Library, London
The Ephemera Society, London
The Wellcome Library, London

Rob Banham, Sally du Bosqu de Beaumont, Jen Calmen, Dave Farey,
Shelley Gruendler, Stephen Lowther, Paul Nash, Alexandre Parré, and
Nigel Roche

. . . and all those anonymous individuals that have contributed their
thoughts and experiences to this book.

Sex sells- but the ladies (and gentlemen) have to sell it. This book explores the advertising medium they created in London to do just that: Tart Cards!

CONTENTS

₣ORᴇPLAY

Think of London and what comes to mind? Double-decker buses, black cabs or Beefeaters guarding the Tower? Nowadays Britain's capital city has a more ephemeral but equally pervasive symbol: tart cards. If you are from out of town and unfamiliar with these things, tart cards are the means by which London prostitutes advertise their services. They have become as ubiquitous a symbol of that city as the red telephone boxes in which they are found. Step in to any Central London call box and you can contemplate up to eighty cards inviting you to be tied, teased, spanked or massaged either in luxury apartments, fully-equipped chambers, or the privacy of your own hotel room. All this and more is just 'one minute away' from the box in which you are standing.

Read the cards in the boxes and you get more than just a hint of an alternative London.

Some people find the cards offensive, others amusing; for the girls and their customers they are a commercial necessity.

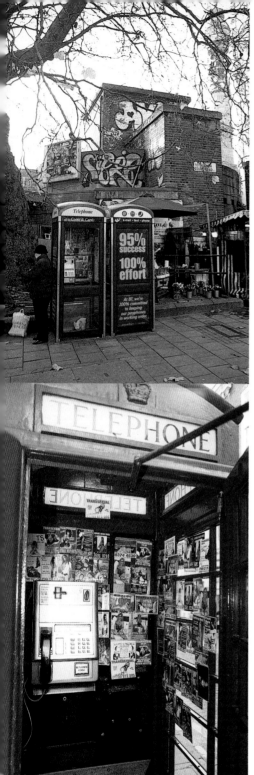

Behind the cards there is

To anyone interested in printing and graphic design the cards form a microcosm of evolving typographic tastes and techniques; for those printers prepared to take the risk, they represent regular and lucrative business. But love them or loath them, tart cards are undoubtedly an intriguing slice of English social history.

Although soliciting with cards is predominantly a modern phenomenon, it does have historical precedents. In Victorian London, prostitutes distributed business cards to theatres and musical halls; the cards were placed in sealed envelopes that were printed with delicately suggestive rhymes. For most of the twentieth century prostitutes publicised their services by placing discrete and euphemistic handwritten notices in news agents' windows: 'French lessons: private tuition from continental rainwear model. Please ring . . .'. Printed cards in telephone boxes first appeared in London in the mid-1980s when a loophole in the law meant they were not, strictly speaking, illegal. It was an effective and cheap way for the girls to advertise their services; and it was both logical, and helpful for the customer, to move the cards directly to the technological interface necessary to arrange business.

The practice of placing prostitutes' cards in phone boxes is known as 'carding'. It is a particularly English phenomenon

brant and well-organised industry...

specific to London and the seaside resorts of Brighton and Hove where they serve a flourishing tourist trade. There have also been small outcrops of cards on the coast of North Lincolnshire that cater for a transient maritime population. Elsewhere in the UK, prostitutes still hold to the older methods of notices in shop windows although advertising in local newspapers is also used.

Behind the cards there is a vibrant and well-organised industry that comprises prostitutes, punters*, pimps and printers. It is an illicit business, but one that is thriving and persistent and where money changes hands swiftly and inconspicuously. Carding started as a kitchen table industry with a handful of prostitutes and their maids cutting out images, drawing their own illustrations, rubbing down lettering and then passing it all over to a trusted printer. It has developed into an extensive, professional, well-organised and highly technical production process that utilises the latest manufacturing systems.

For some people the cards are interesting because they are trackers of technology: they show when specialised production equipment became available, quite literally, at street level. To others the cards are artistic or typographic curios with a unique linguistic and visual vocabulary. The cards are

Printed cards in telephone boxes first appeared in London in the mid 80's.

*clients

TART
CARDS

❤ **BUSTY BLONDE** ❤
HOLBORN/RUSSELL SQ
MIDDAY TO MIDNIGHT
404 - 2358
❤ **MIDWEEK ONLY** ❤

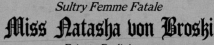

Sultry Femme Fatale
Miss Natasha von Broski
Private Berlin'esque
Cabaret Dancing (Berlin-Lasvagas)
Superb Swedish/Japanese Massage Service
A Labyrinth of Relaxation Mystique
Unequivocal Exotic Pleasure
Hot Towel Treatment *071-388 1298* WC1
11.30-7.30pm

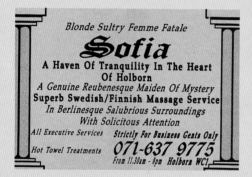

Blonde Sultry Femme Fatale
Sofia
**A Haven Of Tranquility In The Heart
Of Holborn**
A Genuine Reubenesque Maiden Of Mystery
Superb Swedish/Finnish Massage Service
*In Berlinesque Salubrious Surroundings
With Solicitous Attention*
All Executive Services **Strictly For Business Gents Only**
Hot Towel Treatments **071-637 9775**
From 11.30am - 8pm Holborn WC1

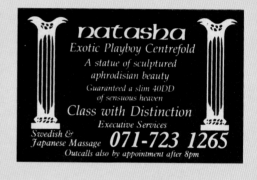

natasha
Exotic Playboy Centrefold
*A statue of sculptured
aphrodisian beauty*
*Guaranteed a slim 40DD
of sensuous heaven*
Class with Distinction
Executive Services
Swedish & **071-723 1265**
Japanese Massage
Outcalls also by appointment after 8pm

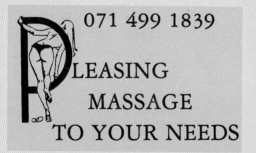

071 499 1839
**PLEASING
MASSAGE
TO YOUR NEEDS**

open at 10 am
**TREAT
YOURSELF**
071 · 491 · 7448
oxford circus

BUSTY BLONDE
404 - 2358

NEW
Charming
Busty . . .
Italian Model

071-499 1796

Charming
French
Model
MAYFAIR
071-499 1839

Graduate Escort
PhD, A & O

IN/OUT CALLS W1

7383 3363

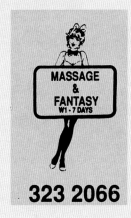

MASSAGE
&
FANTASY
W1 - 7 DAYS

323 2066

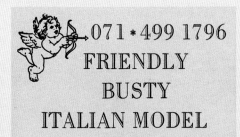

071•499 1796
FRIENDLY
BUSTY
ITALIAN MODEL

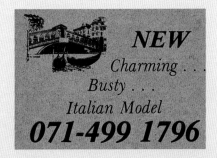

NEW
Charming . . .
Busty . . .
Italian Model
071-499 1796

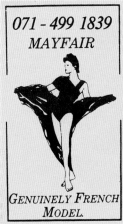

071 - 499 1839
MAYFAIR

*GENUINELY FRENCH
MODEL.*

he early tart cards were small, no bigger than a visiting card. A professional
entleman might easily secrete one into his wallet, conveniently slipping it between
he cards of his stockbroker and shoemaker.

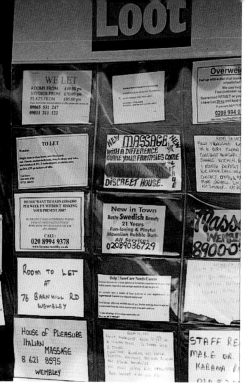

News agent window sign

prostitutes, pur

also sociological and cultural records of the late twentieth century, mirroring the changing sexual attitudes and practices of the past twenty years. There are many British universities, libraries and museums that have extensive collections of these ephemeral items and numerous individuals who have accumulated either selective or near comprehensive collections. Recently, enterprising second-hand book dealers have started selling the cards for extraordinary sums to collectors unable to visit London. The cards have also become something of a cult: there is a montage of them in the BBC America late-night comedy series *So Graham Norton*, and there are Internet web sites devoted to the phenomenon of the cards. This peculiar manifestation of ephemeral street literature has a market value.

But not everyone appreciates tart cards. Some people find them intimidating and offensive and to others they are an unsightly nuisance. For as long as there have been tart cards police, councils, governments, telecommunications companies, the legal profession, local communities and individuals have all been mobilised in an attempt to curtail card production and distribution. Considerable time, money and resources have been used in an effort to combat the spread of tart cards, and various laws have been invoked to try and

rs, pimps and printers

banish the 'girls-in-the-box'. But the prostitutes, pimps and printers have adapted their practices in order to circumvent the law and carding has continued to thrive. However, their days may be numbered as on 1 September 2001 it became a criminal offence to put tart cards in telephone boxes, and anyone convicted of doing so faces a maximum six-month jail sentence or a £5,000 fine.

To date, the cards have maintained their presence. But, just as technology and the law brought the cards into the boxes in the first place and has influenced their design and posting ever since, so technology and legislation will eventually move the cards into other advertising spheres. Prostitution, like the poor, will always be with us and the girls are starting to look for other ways to advertise their services. Many cards already carry web addresses and the oldest profession is now using the newest of technologies.

The oldest profession uses the newest technology: web sites.

7

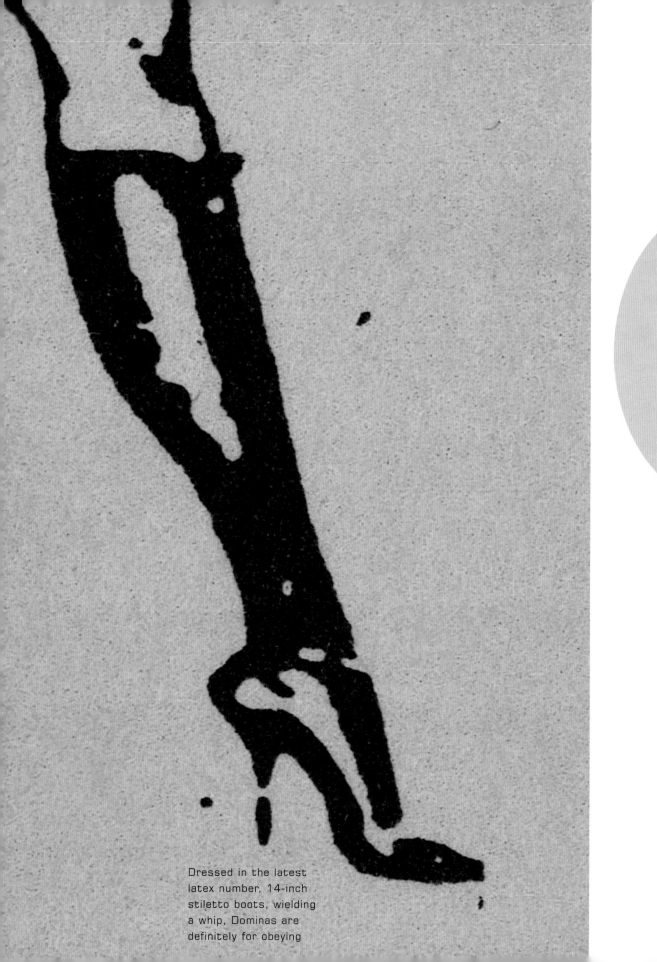

Dressed in the latest
latex number, 14-inch
stiletto boots, wielding
a whip, Dominas are
definitely for obeying

London Sex: YESterday

ONCE A WHORE, ALWAYS A WHORE. From the London of Julius Caesar to that of Tony Blair, Britain's metropolis has always been a centre of dissipation and indulgence and a focus of sexual endeavours. It is not without cause that politicians, poets and puritans have variously described London as a modern Babylon, a cesspool of debauchery and a paradise for pimps.

In Roman times, London was already a lethal cocktail of mercantile aggression mixed with sexual licence. It was a city committed to trade, but for some people their bodies were the only things they had to sell – and there were plenty of others willing to buy. The Romans tolerated the retailing of sex just as they did any other commodity, and encouraged business by licensing the city's brothels. Sex in London has been unceasingly commercial ever since.

In the thirteenth century, Cock Lane in Smithfield became London's first 'red-light' district when it was desig-

9

TART
CARDS

nated for prostitutes and their clients. Smithfield was a centre of trade for meat and cloth; where there was money there was also commercial sex, and in 1241 the market added prostitution to its business. A large number of the girls came from the provinces looking for a good time and profit; they arrived in the city following rumour of its sexual licentiousness and pecuniary benefits. A thriving homosexual community also existed in medieval London. The men allied themselves with whores and brothels and used drinking houses that were much like twentieth-century 'gay bars'. London was undoubtedly the centre of sin in medieval England, and the level of vice in the capital was as great as anything experienced in the current century.

Regency London was a sexual magnet

The number of women in Elizabethan London who tussled with each other to eke out a living through commercial sex was immense. Elizabethan London was a city that was expanding with vehement rapidity. Poverty, commerce, wealth and sex all rubbed shoulders together to produce clearly defined brothel hot spots; the economic conditions of the day insured that prostitution had a tenacious hold over the city. The most infamous brothels, or 'stews' as they were known, were tightly crowded together on the Southwark Bankside, but they could also be found in vast numbers

around Smithfield, Shoreditch, Westminster, Billingsgate and Ave Maria Alley near St Paul's. No modern English town today could have within its boundaries as many prostitutes as Elizabethan London.

In the 1700s the Strand and Covent Garden were popular areas for sexual liaisons. Posture dancers performed eighteenth-century versions of striptease in the pubs; there were brothels that specialised in the popular English vice of flagellation; and there were 'Mollie Houses' that were the haunts of homosexuals. Regency London was a sexual magnet; girls 'newly come upon the town' were lured to the capital from the regions in anticipation of high earnings and low abandonment; and sex tourists from both home and abroad visited the city in search of vice. Anyone interested in calling on one of London's brothels could buy a guidebook, *Harris's List of Covent Garden Ladies*, to help them find a prostitute suitable for their taste and income. *Harris's List* was published annually and was aimed at the wealthy client. It had a circulation of around 8,000 copies and listed the names and addresses, physical appearance, specialities and charges of those London prostitutes who thought it worthwhile to appear in the gazetteer. There were about eighty girls listed in each edition.

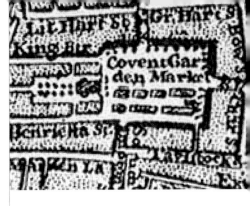

18th-century map of Covent Garden

21st-century map of Covent Garden printed on the reverse of a modern tart card.

MISS B____RN. NO. 18 OLD COMPTON STREET, SOHO CLOSE IN THE ARMS SHE LANGUISHINGLY LIES WITH DYING LOOKS, SHORT BREATH, AND WISHING EYES.

THIS ACCOMPLISHED NYMPH HAS JUST ATTAINED HER EIGHTEENTH YEAR, AND FRAUGHT WITH EVERY PERFECTION, ENTERS A VOLUNTEER IN THE FIELD OF VENUS. SHE PLAYS ON THE PIANOFORTE, SINGS, DANCES, AND IS MISTRESS OF

TART CARDS

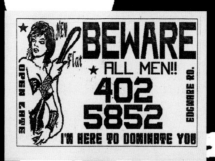

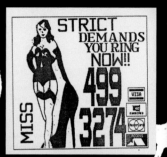

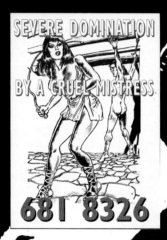

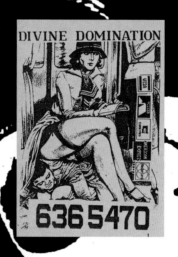

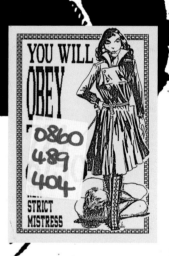

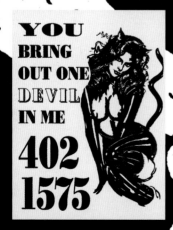

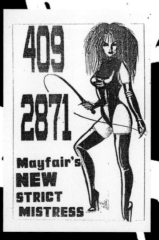

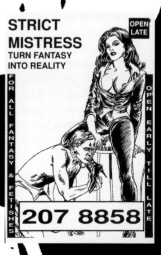

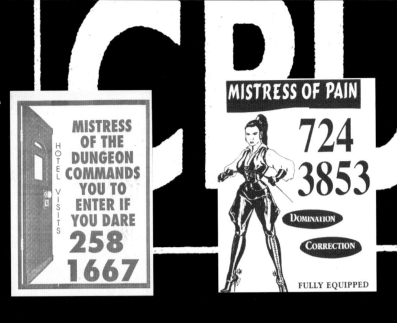
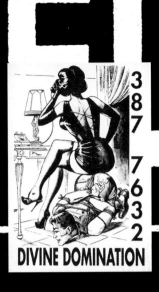
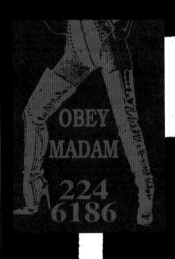
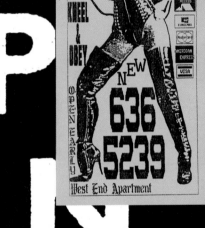
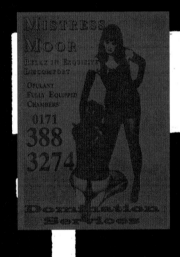
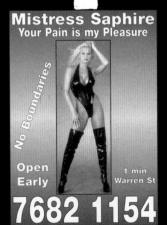
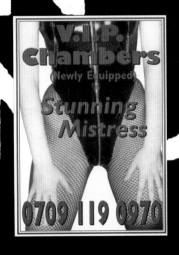
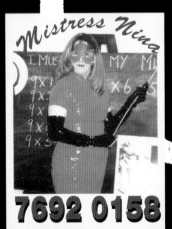
Second only to corporal punishment the British male likes to be dominated by mistresses with such evocative names as Madam Storm, Mistress Scarlet or Goddess Raven Rose.

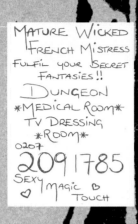

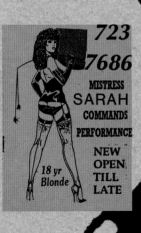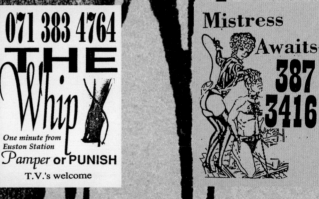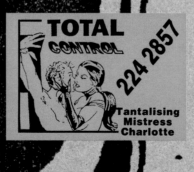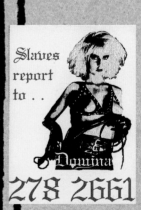

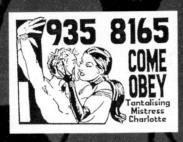

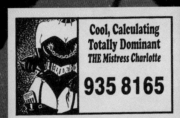

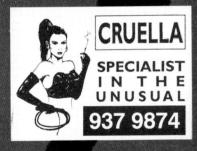
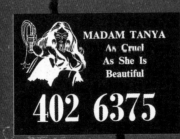
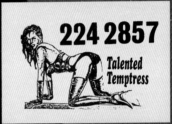
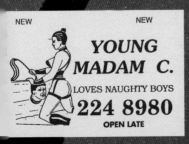

A true dominatrix dressed in the latest latex number, 14-inch stiletto boots and yielding a whip is not a prostitute and woe betide any client who thinks otherwise.

a 'threepenny-upright' on th

EVERY MANOEUVRE IN THE AMOROUS CONTEST THAT
CAN ENHANCE THE COMING PLEASURE; IS OF THE
MIDDLE STATURE, FINE AUBURN HAIR, DARK EYES
AND VERY INVITING COUNTENANCE, WHICH EVER
SEEMS TO BEAM DELIGHT AND LOVE.
IN BED SHE IS ALL THE HEART CAN WISH,
OR EYES ADMIRE, EVERY LIMB IS SYMMETRY, EVERY
ACTION UNDER COVER TRULY AMOROUS; HER PRICE
TWO POUNDS. [EQUIVALENT TO £120 TODAY]

Not all the girls were that expensive. Then as now, London supported several different classes of prostitute and their rates varied greatly: fifty guineas for a girl with some class; a pint of wine and a shilling for a streetwalker on the Strand; or a 'threepenny-upright' on the bridge at Blackfriars. A homosexual liaison cost five guineas; ten guineas would buy a risqué game of cards. A lady looking to be 'well-mounted' had to be prepared to part with fifty guineas.

The sexual ambience of nineteenth-century London was as lascivious as anything that had gone before. London was the largest urban area in Britain, ten times greater than the fastest growing of the new industrial towns. With its size came notoriety and it fascinated and attracted people with a wide variety of interests. Prostitution, or the Great Social Evil as contempo-

Flora Tristan, a French
socialist and feminist

ridge at Blackfriars

raries called it, was endemic and existed to a degree that compared unfavourably, or favourably depending on your perspective, with mainland Europe. The Prime Minister, William Gladstone, told the House of Commons in 1857 'as respecting the gross evils of prostitution, there is hardly any country in the world where they prevail to a greater extent than our own'; a view that was corroborated by Scotland Yard. The notoriously prudish British tolerated prostitution on a scale so vast that Flora Tristan, a French socialist and feminist who visited London, wrote with shock and amazement:

> THERE ARE SO MANY PROSTITUTES IN LONDON THAT ONE SEES THEM AT ANY TIME OF DAY; ALL THE STREETS SEEM FULL OF THEM, BUT AT CERTAIN TIMES THEY FLOCK IN FROM THE OUTLYING DISTRICTS IN WHICH MOST OF THEM LIVE, AND MINGLE WITH THE CROWDS IN THEATRES AND PUBLIC PLACES. IT IS RARE FOR THEM TO TAKE MEN HOME; THEIR LANDLORDS WOULD OBJECT, AND BESIDES THEIR LODGINGS ARE UNFIT. THEY TAKE THEIR 'CAPTURES' TO THE HOUSES RESERVED FOR THEIR TRADE . . .

Victorian London had one of the largest commercial sex industries in the world: it is an accolade still attributable to London of the twenty-first century.

MISS B – LFORD, TITCHFIELD-STREET.

This child of love looks very well when drest. She is rather subject to fits, alias counterfits, very partial to a Pantomime Player at Covent Garden Theatre. She may be about nineteen, very genteel, with a beautiful neck and chest, and most elegantly moulded breasts, her eyes are wonderfully piercing and expressive. She is always lively, merry and cheerful, and in bed, will give you such convincing proofs of her attachment to love's game, that if you leave one guinea behind, you will certainly be tempted to renew your visits.

– Advertisement from Harris's List of Covent-Garden Ladies, ca. 1740

TART CARDS

London Sex:

TODAY

B RITAIN'S CAPITAL, TODAY, IS IN
the culinary super-league and restaurant-goers can sample
the delights of kitchens from Amsterdam to Vietnam. For the
sexual gourmand London is also a world café that offers deli-
cacies and indelicacies that appeal to every palate and which
serve an international market. London is a sexy and licentious
city. There are bars full of strippers; clubs where girls will
dance on your lap or perform with a pole; there are peep
shows, sex shows and bed shows, and an inexhaustible num-
ber of bars and clubs that provide for every sexual perversity.
There are fairs that cater for the fetishist; balls for sex mani-
acs; and parties that promote sexual freedom. There are
countless adult bookstores and cinemas; shops that will clothe
you in rubber and pierce you for pleasure; and other, more
specialist retailers that venture into increasingly far-flung
sexual domains. Behind London's dignified façade there are
rooms transformed into dungeons, and men transformed into

TART
CARDS

women; there are school rooms where naughty boys are spanked and medical rooms where adults play doctor and nurse. There are streets known for prostitution and parks and riverbank promenades used for cruising. The city has a voracious and insatiable sexual appetite and is inexorably fecund in its provision of alternative realities. However extraordinary the Zeitgeist, London can provide round-the-clock satisfaction.

'London', according to one habitual and well-travelled

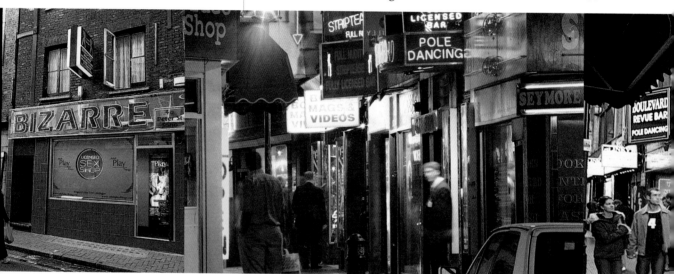

Behind London's dignified façade there are rooms transformed into dungeons, and men transformed into women; there are school rooms where naughty boys are spanked and medical rooms where adults play doctor and nurse.

client 'is one of the best cities in the world for indulging in commercial sex; the crime rate is very low compared to other major cities, especially in the central tourist areas; and the women are friendly and eager to please, provided you treat them with the respect they deserve'.

But is all this sexual bounty legal?

Like most other European countries it is not a criminal offence to work as a prostitute in the UK, but the allied trades of the business – soliciting, advertising, handling money from clients, brothel-keeping, and living off the earnings of prostitution – are all forbidden by law. Consequently, a girl's

activities are rather limited by the prohibitions imposed upon her support services, and the only form of prostitution that does not attract prosecution is that carried out by a girl working alone in her own home.

The main legislation governing prostitution in the UK is the *Sexual Offences Act 1956*, which deals with off-street prostitution. In addition, the *Street Offences Act 1959* and the *Sexual Offences Act 1985* are concerned with street prostitution and

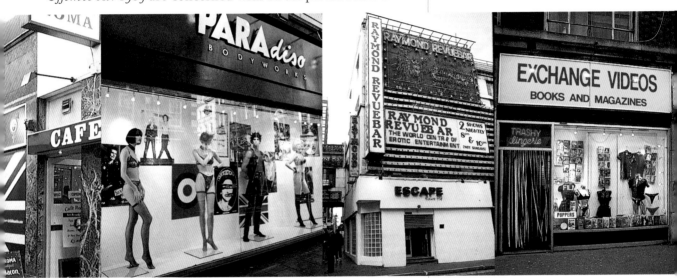

kerb crawling. Under the *Act of 1956*, it is a criminal offence to keep a brothel or to let premises for use as a brothel. In practice this means that prostitutes may not share premises as one of them can be prosecuted as the brothel keeper, and that landlords inflate the rent charged to prostitutes to compensate for the risk of prosecution. A man cohabiting with, or who is often in the company of a prostitute, is presumed to be living on immoral earnings and guilty of a criminal offence unless he can prove the contrary. Likewise, anyone advertising on behalf of a prostitute is also liable to prosecution for living off immoral earnings: a shopkeeper displaying

21

The girls are not the only ones who use the cards to find customers – the men do as well.

advertisements in the window; newspapers and magazines carrying small ads for sexual services; or those who print or place the advertising cards in telephone boxes. If prostitution behind closed doors is against the law, then undoubtedly so is on-street prostitution. The *Sexual Offences Act 1985* made kerb

42,000 visits mad

crawling illegal. The girl does not need to be caught soliciting in either words or deeds, it is enough that a client simply indicates that he requires her services.

But despite the law and its hindrances, many thousands of men and women in London still engage in the age-old business of commercial sex.

There are about 70,000 prostitutes – girls, boys and transsexuals – working in the UK. The sex industry is a flourishing business and with 42,000 visits made daily to working girls it is estimated to generate up to £1 billion a year. More money is spent on sex than going to the cinema.

There are several different categories of prostitute. The streetworkers represent a branch of the profession that is both illegal and fraught with dangers for girls and their clients alike. A safer, but still illegal, form of prostitution is carried out in the large number of massage parlours and saunas that occupy London's streets and which obliquely offer 'extra services' that are available at additional cost. Some massage parlours are fronts for brothels. More overt are the Soho clip joints. Located in London's most commercial of sex areas between Shaftsbury Avenue and Oxford Street, clip joints claim to offer live sex shows, peep shows or bed shows, and they usually have touts outside calling to

passers-by who, once lured inside, are charged outrageous prices for drinks and the company of the hostess.

Walk-ups are apartment buildings where the front doors are left open and people passing by are tempted in by hand-made signs that are taped to the walls just inside advertising:

aily to working girls

'Charming, busty Italian model, 2nd Floor'. Walking up and ringing the bell does not obligate a client to do business with the girl; he can simply ask to see her, find out her rates for services, and decide whether or not she appeals. The signs, surprisingly perhaps, are unusually accurate, most of the girls are 'young, friendly' and usually with 'nice bodies'. The most popular area for walk-ups is Soho, particularly along Old Compton Street between Charing Cross Road and Wardour Street, as well as the streets behind the Raymond Revue Bar – Berwick Street, Peter Street and Duck Lane. Chinatown also has a few walk-ups, mainly along Lisle Street. There are some in Shepherd Market in Mayfair, just north of Piccadilly and south of Curzon Street. Despite their sleazy and dilapidated appearance, the walk-ups are safe.

Then there are the escort girls. This is a form of prostitution where the client can engage the services of a male or female prostitute in the guise of a companion or escort who will, for a fee, accompany the client to parties, restaurants or clubs and, if asked, will also provide sexual services. Escort girls either work from their own apartments or for an agency. They advertise widely in contact magazines, on the Internet or on the cards in telephone boxes.

23

TART
CARDS

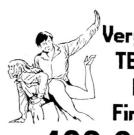
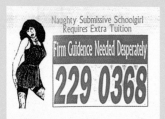
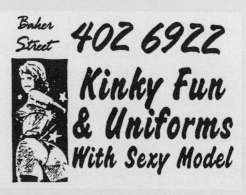
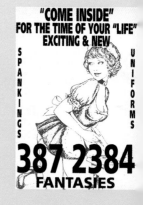
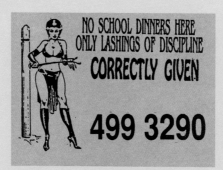
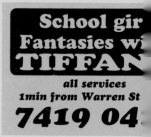
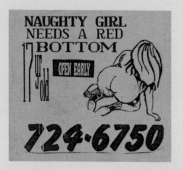
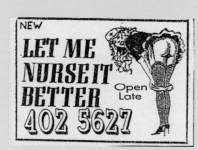
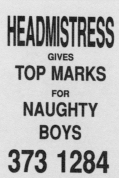

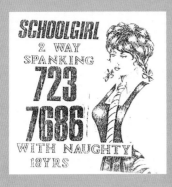

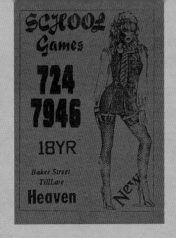

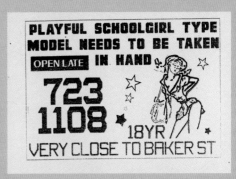

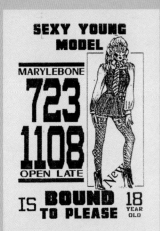

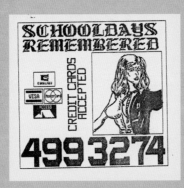

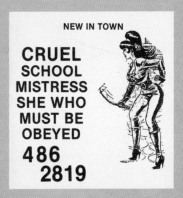

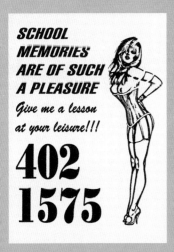

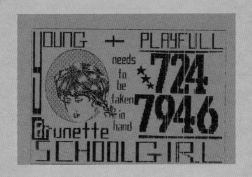

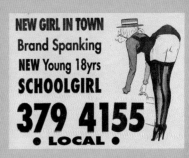

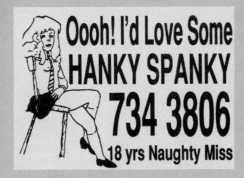

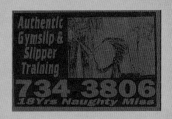

Let's pretend' is the basis of most commercial sex. The entertainments offered by role play cards are grown-up versions of children's games. Some involve no more than dressing up; other are full reenactments.

Games might take place in authentic Victorian school rooms complete with wooden desks, blackboards and, of course, corporal punishment for naughty boys.

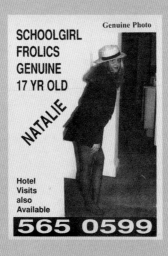

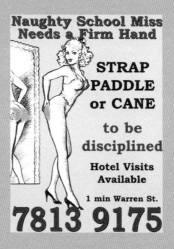

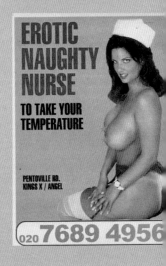

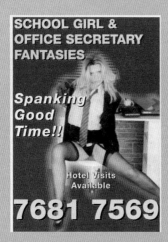

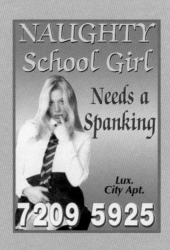

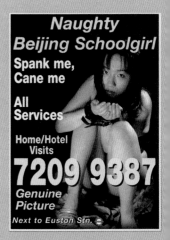

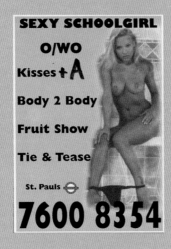

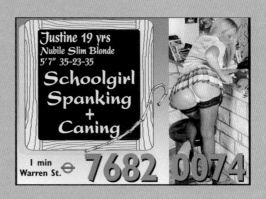

Finally there are the girls who work from 'luxury apartments' scattered across the length and breadth of London. Many of them are also available for hotel and home visits. These girls advertise their services in news agents' windows, local papers, contact magazines, the Internet or on cards stuck to the inside of telephone boxes. By ringing the number the client will be given directions to the flat where he can meet the girl and see if he likes her. The girls do not generally own the flats. The owners may be directly involved in the business of prostitution, or they might be remote figures that merely collect the rent and turn a blind eye to the business. Each flat employs a 'maid' who acts as receptionist, maintains the appearance of the flat, and looks after the girls. Occasionally, the 'maid' may also be the owner. The number of girls to a flat varies enormously: some are worked by a single girl, others by up to ten girls each doing twelve-hour shifts in order to give a seven-days-a-week, twenty-four-hours-a-day service. The range of provisions that are on offer are limitless: anal, BDSM, corporal punishment, domination, fetish, massage, oral, role play, toilet, transvestites, transsexuals and gays all rank high among London's favourite predilections.

Prostitution is a variable trade and a girl's income can fluctuate tremendously from one week to the next. There is hardly any business that operates in such a financially uncontrolled manner as the sex industry. 'Storm', a Central London dominatrix complained her business was suffering 'because of all the girls that come over from Eastern Europe and will have sex for less money than us English girls, and will do it without a condom, then the punters expect us to do the same, we are being forced to do it cheaper'.

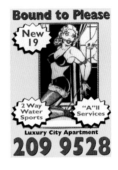

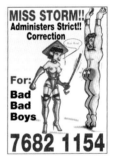

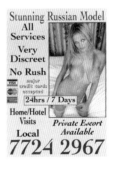

27

At a rate of 1.6 US dollars to the English pound:	
UK£	US$
20	32
50	80
80	128
120	192
200	320

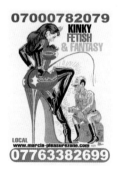

London is inexorably fecun

But with prostitution, as with most other industries, you get what you pay for.

Some prostitutes charge by the activity, and others work strictly by time. The cheapest rates in London are for street-workers who will charge as little as £5 to £20 for personal services uncomfortably rendered in insalubrious outdoor venues. In the Soho walk-ups a quick 'French plus sex' starts at £20. The rates are highest for prostitutes who operate from flats. A thirty-minute in-call (when a client visits a girl at her place of work) will cost between £50 and £60 for intercourse or oral sex, rising to £80 for sex without a condom, and upwards of £120 for anal sex or a lesbian show. Out-calls (where the girl meets the client in an hotel room or at his home) start at around £200.

Most of the girls have a sliding scale of charges depending on the duration and complexity of service being provided. 'Marcia' and the girls at north London's Pleasurezone work from a luxury basement flat with two fully equipped playrooms near Kings Cross Station. Strategically located to capture the tourist and business commuter, their prices reflect their clientele. 'Marcia' has two price lists: one for clients seeking 'massage' or straight sex; another for those looking for more specialist services. A half-hour massage and hand relief comes to £40 to

£60, while a half-hour full-wax costs £60 to £80, and a massage plus 'O & A' totals £80 to £100. If a client wants a full hour of pleasure then the prices increase proportionately. Massage, sex, oral, reversed oral, bubble-bath, and breast relief are all charged at £120 to £150; an extended stay is in excess of £250. A full hour with two girls giving VIP services is £250, rising to £450 for two hours and over £500 for an extended session. Clients visiting 'Marcia' for domination can expect to pay more: £80 for a half-hour or £150 for an hour. One hour of domination with a sensual tie and tease costs £200, with an additional £50 if water-sports are included. Add some champagne and caviar and the price rises to £300; stay longer than two hours and the tariff increases to £500. 'Marcia' also has something for those with an eye for a bargain: there is an 'overnight stay special' which for £800 to £1000 includes two mistresses and brunch.

The vices offered by today's prostitutes have not altered over the centuries nor, proportionately, have their prices or the locations from which they work. But the means by which they advertise have certainly progressed.

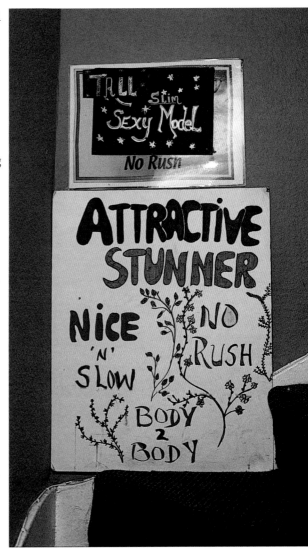

Walk-ups are apartment buildings where the front doors are left open and people passing by are tempted in by the handmade signs that are taped to the walls just inside.

the **RISE** of the cards

I F SEX SELLS, THEN PROSTITUTES
should be the most prosperous and accomplished of advertis-
ers. But for most of their history London's prostitutes have
had to rely on body language and word of mouth to attract
business: Victorian courtesans, the demi-monde or 'pretty
horse breakers' sought out rich men by riding in Hyde Park
dressed in ravishing riding habits and beaver skin hats; whilst
the street girls were compelled to walk the pavements 'decked
with the gaudy trappings of their shame'; prostitutes of the
twenty-first century have their own dress code and recline
provocatively (as the cinema would have us believe) under
street-corner lamp-posts. A prostitute's body language is a
form of advertising that is instantly recognisable, easily com-
prehended, and as old as the profession itself. Until recently,
they have made few forays into printed publicity.

In 1956 soliciting on the streets of Britain became illegal,
and prostitutes had to find alternative methods of publicising

31

their services. A new marketplace was established when, for a few pence a week, the girls began placing postcards in friendly news agents' and tobacconists' windows or in the special glass showcases that often hang next to shop doors. Amongst the advertisements for furnished studio rentals, second-hand pianos and hedge trimming, there appeared handwritten cards containing announcements for models and masseuses. French and Swedish lessons became top of the UK's extra-curricular activities; gym mistresses appeared offering instruction in physical exercise; governesses by the name of 'Miss Swish', 'Miss Birch' or 'Miss Cane' advertised their expertise in dispensing 'corrective treatment'; and there were occasional advertisements for those whose hobbies included rubber: 'I make all my rainwear: model available evenings: ring Angela . . .'. But the majority of the cards were for prostitutes whose talents were unspecified.

It was not possible in 1956 to advertise in telephone boxes because the *Post Office Act 1953* had made it an offence by stating:

'A person shall not without due authority affix or attempt to affix any placard, advertisement, notice, list, document, board or thing in or on, or paint or tar, any Post Office letter box, telegraph post or other property belonging to or used by or on behalf of the Postmaster-General, and shall not in anyway disfigure any such office, box, post or property.'

The Post Office Act 1953

This offence was created at a time when the Post Office was a Government department, and telecommunications were a monopoly. It continued to be a crime until it was repealed upon the privatisation of British Telecom in 1984. A gap had opened up in the law, some of the girls saw their chance and moved their advertising out of the shop windows and into the

telephone boxes: thus a new genre of street literature was born.

So beginning in 1984 telephone boxes covered in cards advertising sexual services became a common sight in London. The boxes began to take on the appearance of miniature pop-art galleries with some of them festooned with as many as eighty brightly coloured cards. The cards carried images of women, sometimes transsexuals, and occasionally men; a phone number, but rarely an address; and either a suggestion of, or an explicit listing for, the available sexual services. The practice was not, and is not, uniform across the UK or even within the larger cities. Although there are examples elsewhere, the largest number of cards are confined to parts of Central London and Brighton and Hove.

There were several advantages to moving the publicity into the call boxes. Firstly, telephone boxes provided the means for a client to respond immediately to the advertisement. But the greatest advantage was free media space. Telephone boxes make it physically possible for the girls to place an advert without the knowledge or consent of the owner and without paying for the space. This is not feasible with more traditional media such as newspapers, magazines or shop windows. It is not known how many telephone boxes there are in Central London that information, according to BT is an official secret – but there are probably in excess of 1000: this gives the girls a huge number of sites in which to display an unlimited number of cards, for as long as they need and as frequently as they want.

The business of manufacturing and posting cards is intense and the volumes involved are enormous, but it is a business where it is notoriously difficult to get hard facts and figures. However, it has been estimated over 13 million cards are

TART
CARDS

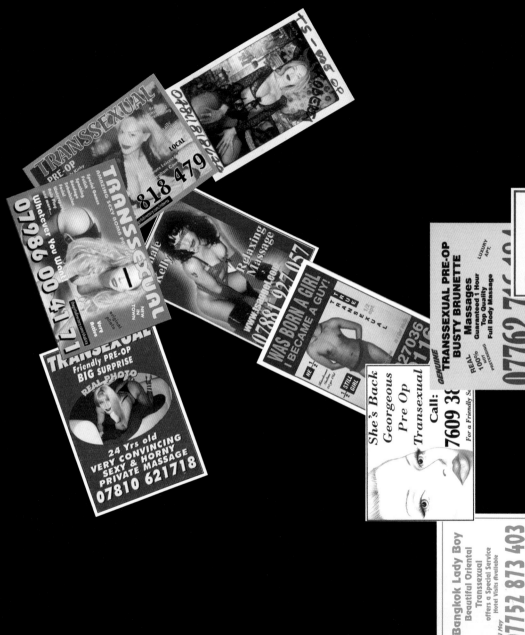

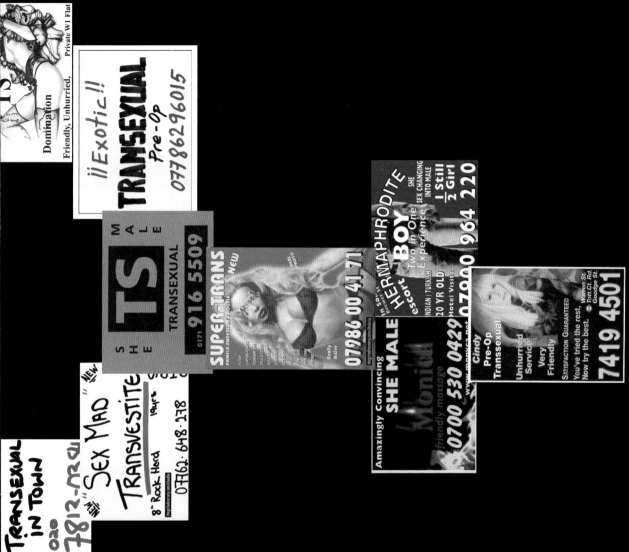

The photos on the transsexual tart cards may be men feigning to be women, or women pretending to be men pretending to be women. It all gets very confusing, but it is the ambiguity that provides the fun.

deposited in Central London phone boxes each year, equating to 250,000 a week, or 35,600 cards a day. Telecommunications operators calculated in 1997 that there were around 650 women operating in this way in London, touting for business at the end of 400 different phone lines. A more recent esti-

Some girls have ta

mate suggests that there are only 250 prostitutes working from cards, and if this is the case, each girl requires a staggering 52,000 cards a year and will put out over 1000 cards a week, or 150 cards a day.

The cards are placed in the boxes on behalf of the girls by people known as 'carders' who are frequently students or unemployed. It is a highly lucrative trade and the carders can earn an average of £30 per 100 or £200 per day for between 600 and 700 cards placed. The girls pay for carders out of their own wages, and with 13 million cards placed annually the wages of sin, as far as carding is concerned, is in the region of £4 million. In the London borough of Westminster alone there are approximately 150 carders operating, another 24 covering the Soho area, and 59 carders have been prosecuted in Paddington. 'Shaun' works for four flats, and notes that he 'also distributes for a mate who has three flats of his own. Given that each flat could have up to ten girls working there, that's a lot of girls wanting to advertise their services and hundreds and hundreds of cards'. Carders work quickly, stopping only for a brief moment at each telephone box in the areas where the cards are to be posted, and frequently revisiting the boxes to replace any that get removed either by the police, cleaners, the public or rival

Over 13 million cards are deposited in Central London phone boxes each year

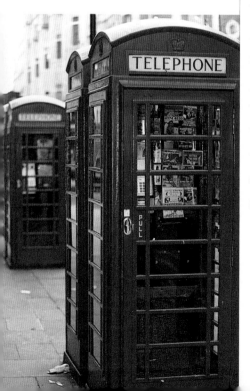

carders. A good carder is difficult to find, but once found, can considerably contribute to the success of the girls' activities. However, since it became a criminal offence, fewer people have been willing to take the risk of posting, and many girls complain that 'most carders are now alcoholics

n to posting their own cards

or drug addicts who can't get themselves out of bed in the morning and they have started to increase their prices'. Some girls have taken to posting their own cards.

Within London, the cards only appear in certain areas: generally in the more anonymous centre of the city where the girls hope to attract tourists and businessmen and where, because of the transient population, there are fewer community shops displaying cards for local services. In other, more residential parts of the capital, the girls still maintain the older methods of advertising in shop windows.

There are six areas within Central London where the display of cards in telephone boxes is particularly strong. In each area the girls are catering for very particular clients.

W1 is a central square with corners at the tube stations on Edgware Road, Euston Square, Leicester Square and Hyde Park Corner. It takes in the heavily visited tourist areas of Oxford Street and Circus, Piccadilly and Soho, Park Lane and the Shepherd Market areas. WC1 has corners at Euston Square station, Claremont Square in the Pentonville Road, Chancery Lane, and Tottenham Court Road stations. The girls working this patch are aiming at the businessmen and lawyers that work in Russell Square, Gray's Inn Road and Holborn. NW1 forms a rough triangle with corners at

37

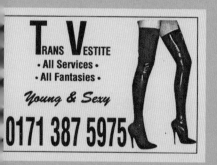
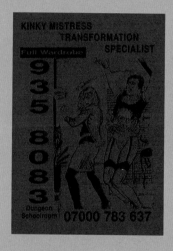
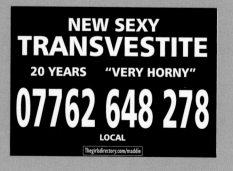

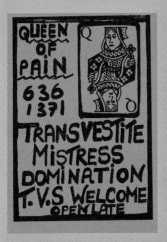
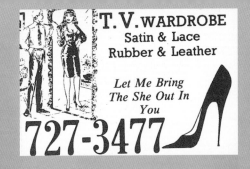
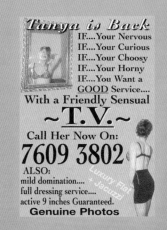
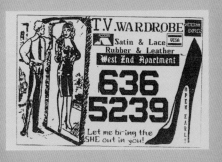

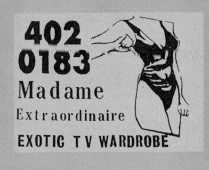
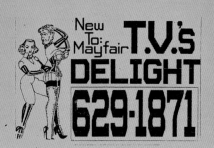
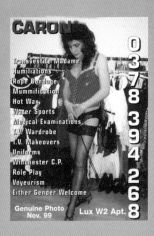
Transvestites seek pleasure from wearing the clothes of the opposite sex. The genders of the service providers are mixed; girls catering to **TV** men with 'full' wardrobes and make-up, and self-professed **TV** men offering '9 inches' and discipline.

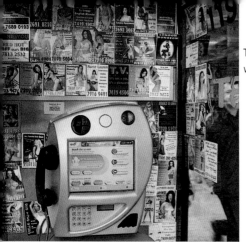

The boxes began to take on the appearance of miniature pop-art galleries with some of them festooned with as many as eighty brightly coloured cards.

Edgware Road, the Camden Road/York Way intersection, and Kings Cross station. It is a down-at-heel area with a transient community passing through Marylebone, Baker Street, Camden Town, Euston and St Pancras stations. It is also an area for drug addicts. W2 stretches between Westbourne Park station, Maida Vale, Hyde Park Corner, and Palace Gate at Kensington Gardens, including Hyde Park and Kensington Gardens, the Paddington area and Bayswater. It is home to a well-heeled Arab community, foreign embassy staff, and cheap hotels used by young, solo travelers. SW1 extends between Knightsbridge, Piccadilly Circus, and the Thames from Hungerford Bridge (Charing Cross) down to Chelsea Bridge. It includes Victoria, Sloane Square, Belgravia, Kings Road, Pimlico and Vauxhall, St James's Park and Green Park. It is the haunt of politicians and their staff. Finally, there is WC2 with corners at Tottenham Court Road and Chancery Lane stations and the river near Aldwych back to Hungerford Bridge. It includes Covent Garden and Drury Lane, Leicester Square, Seven Dials and the Strand, and the rest of Holborn. This is an area that has been a major centre of prostitution for hundreds of years; today's girls keep that tradition alive.

. . . governesses by the name of 'Miss Swish', 'Miss Birch' or 'Miss Cane' advertised their expertise in dispensing 'corrective treatment'.

Men who spend all week in the driving seat at work surrender themselves to their local dominatrix when it's time to rest and play.

the **FALL** of the cards

OR AS LONG AS PEOPLE HAVE BEEN putting up cards, there have been other people – official and unofficial – taking them down. You can try to take the cards out of the city, but you won't take the city out of the people who put them there in the first place. With every passing law and obstacle the carders have used their street wisdom to circumvent the system, and the 'girls-in-the-box' have remained firmly in place.

The objections to the cards are numerous and various, Corporate organisations and private individuals alike have viewed prostitutes' cards in telephone boxes as 'excessive and objectionable,' branding them an unwelcome and unacceptable nuisance to local communities and 'offensive and intimidating' to the public. They have expressed concern at the bad impression the cards may give foreign visitors to the UK, and the inappropriate influence they might have on young people. When attached to telephone boxes, the cards

43

This card is cut out badly; part of the next card appears on the right edgea

sometimes hide important emergency and public service information; and when they become unattached they are thought to cause litter problems, creating an impression of untidiness and an environmental hazard that requires local authorities to incur costs through cleaning operations. Some members of both the public and council cleaning teams find

There has been more than on

the behaviour of the carders abusive and threatening and have reported incidents of violence towards them from the carders. This is unusual, but such acts have reinforced the feelings of intimidation and threat which a minority of the public experience when using phone boxes. Teachers and parents at one London school complained that pupils as young as five had invented their own version of the Pokémon card collecting craze using prostitute cards that they collected then swapped. There has been more than one actress and model that has been alarmed to find her photograph used without permission on the cards.

Local councils in both London and Brighton and Hove regard the cards as a nuisance. One London councillor viewed them as 'lurid and often pornographic' and he was concerned that they 'defaced and shamed' the city. Over the years, local councils have taken the problem into their own hands and attempted to control the cards by various pieces of legislation, but with limited success.

The *Criminal Damage Act 1971* has been used to prosecute carders for damaging phone boxes. The basis for the prosecutions was that by sticking advertisements to the boxes with adhesive or by using self-adhesive stickers the carders were damaging the boxes. However, the carders took notice of the

law and changed their practices by replacing stickers with cards that were tucked behind some part of the equipment or attached to the windows and walls with 'Blu tac', which does not constitute criminal damage. The *Indecent Displays Act 1981* makes it an offence to display material in public that might cause offence or which is obscene or indecent. Again the girls adapted their practices to ensure the cards did not contain images likely to be found improper or obscene, and helpful printers superimposed stars over the photographs in order to avoid the censor. The *Environmental Protection Act 1990* has also been invoked to prosecute carders on the basis that when cards become detached from phone boxes they turn into litter. But this is a difficult law to enforce: to be successful, the offence of littering must have taken place in a public open space, and this excludes the old-style red telephone boxes that are totally enclosed. Finally, the *Town and Country Planning Act 1990* states it is an offence to display advertisements other than those authorised by the local authority. The problem with this law is that it only applies to those cards that are visible from outside a phone box; it does not include those cards left face down on a shelf.

The fines imposed were minimal. Carders, if they were caught, were fined a mere £200, which they viewed as an occu-

TART
CARDS

oral, anal, toilet gallery

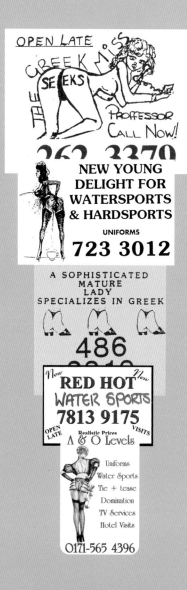

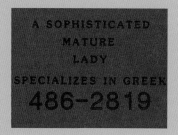
Oral and anal are popular sexual proclivities, but you have to know the lingo to get the service. If a girl advertises she has 'O & A levels' she is not referring to her educational achievements. . .

pational hazard and a known expense to the business. The prostitutes and their carders managed to beat the law at every turn.

The telecommunications operators also attempted to crack down on carding. To the phone operators the cards represented a problem on a number of fronts including the cost of removing them. One company, British Telecom (BT), conservatively estimated that unauthorised advertising in its call boxes cost it £250,000 per annum. This was in addition to the day-to-day cost of cleaning and maintenance of phone boxes, and did not include time spent by senior management in dealing with the problem. The telephone operators were also concerned at the potential lost revenue as the very presence of the cards was felt to deter customers from using particular phone boxes. They also considered that the nature and volume of the cards might affect the image they wished to promote – an important issue in the UK's increasingly competitive telecommunications market.

Frequent daily cleaning programmes by councils and telecommunications companies to remove cards proved ineffective and expensive. No sooner were the cards removed, than teams of watchful carders would replace them.

BT made further attempts to combat the cards by amending its customer contract in order to stop any advertising in a public call box that carried a BT number. Where a customer advertised this way, BT had the right to bar all incoming calls to the advertised number. In the first few months more than 44,000 cards were collected, their numbers processed and 150 warning letters sent out. The girls responded by changing their telephone suppliers or switching to mobile telephones.

Despite the efforts of local councils and telecommunications operators to minimise or eradicate the cards, the 'girls-

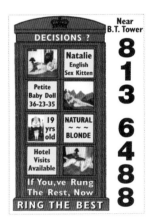

While BT fought them, the girls used the BT tower as a landmark.

47

TART CARDS

...to find her photograph used without perm

in-the-box' continued to proliferate. The Home Office was eventually encouraged to intervene and consider the problem. After consultation with bodies that included the police, telephone companies, local government, the London Tourist Board, the Advertisers Association, residents associations and groups representing sex workers, the Government brought in new measures to crack down on the cards. A new law under the *Criminal Justice and Police Act* was brought in on 1 September 2001 that made displaying tart cards an arrestable and recordable offence. Police were given the authority to take direct action against carders, and those arrested can have their cards seized and destroyed and may face up to £5,000 fine or six months imprisonment.

But not everyone feels the law is a sufficient deterrent and a number of individuals have taken things into their own hands and joined forces to form an organisation which aims to stop the phone-box advertising of prostitution. 'Adoptabox' comprises a group of people who live or work in Central London and who 'care about the environment we work in and the atmosphere we offer to visitors'. Their objections to the cards are they 'degrade women, corrupt children, discourage tourism, depress business and insult international visitors'. Each member has adopted a telephone box that is usually

Every time they pass their phone-box, 'Adoptabox' members clean out the cards and bin them, which is no small task as the illustration of this phone box shows.

targeted by the carders and every time they pass their box they clean out the cards and bin them.

What have been the reactions of the carders and the girls to all the newly introduced legislation and the outburst of civic pride shown by the minority?

Some of the carders have changed their working times to

on on the cards

between midnight and five in the morning to avoid the interest of the police and public. Others have taken to removing their own cards at dawn to avoid them being confiscated and replace them again at night. Some of the cards have reverted to purely typographic advertising in an attempt to escape prosecution. Certainly the local newspapers have seen an increase in the number of small ads they are carrying for massage parlours, saunas and escort services. But despite all, the cards are still in the boxes.

As an alternative to cards in call boxes, it has been suggested that a directory of London sexual services be published, an old solution to a new problem that finds its roots in the eighteenth century and *Harris's List of Covent Garden Ladies*. Nothing is ever really new in the world of commercial sex in London.

Local newspapers have seen an increase in the number of small ads they are carrying.

49

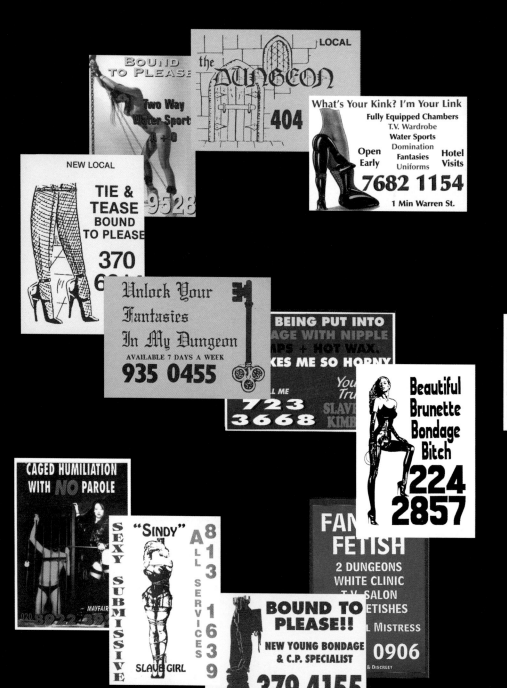

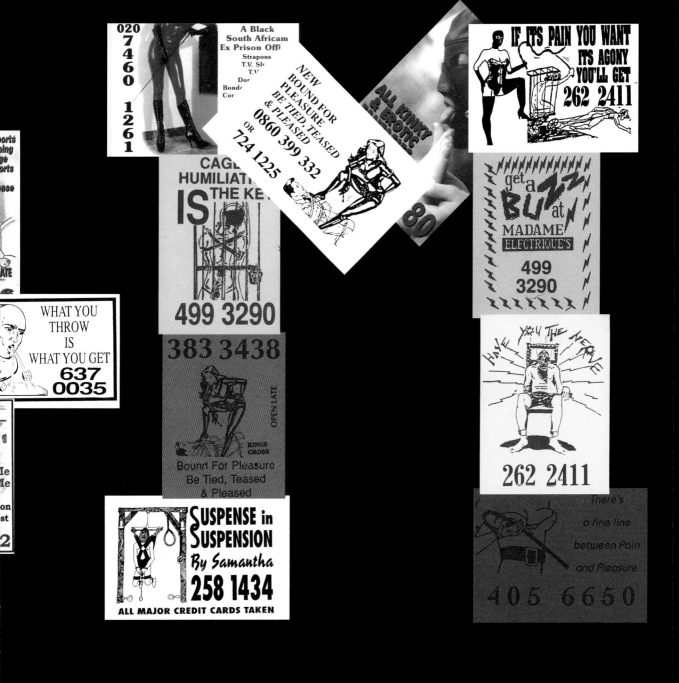

While some cards in this category seem almost playful, others promise a more serious
ose of bondage and sadomasochism treatment. The language is important: a buzz,
or example, is electric shock treatment.

VIEW

6

T

ART CARDS CANNOT BE
turned off, tuned out, or turned over. They have a continuous
presence in London and are seen all day every day; as a form
of advertising the tart card is an important business. The
objectives of the cards are primarily to make people aware of
the products, announce the services and remind those who
already know of their existence. In some instances they act as
a trigger for the impulse buyer.

But how successful are they as an advertising medium?

'Very,' according to Madam Shibari, a dominatrix work-
ing near Baker Street who has been using cards for five
years, 'all my favourite boys come from the cards, all my
nicest and most regular clients are got that way'. She also
publicises herself in magazines and on the Internet, but her
own market research suggests the greater proportion of
clients arrive through the cards. However it is an expensive
way to advertise, and since carding became a criminal

53

TART
CARDS

offence, reliable carders have become scarce and those still working have increased their charges. Madam Shibari pays her carder £175 for a five-day week; he will post 300 cards a day yielding two or three customers. The radius in which she advertises is dependent upon the state of business: 'it's quiet

'All my favourit

at the moment, so I advertise as far afield as possible, but you need a good, swift and reliable carder to be able to do that, one that can cover the ground quickly'.

Madam Shibari is unusual in employing a designer, which is an expense in addition to printing. The styling of her cards is left to the designer. She provides the text and her designer illustrates and selects the typeface. She works from cards of various designs; all are monochrome and each advertises a particular service. None carry photographs.

AS SOON AS YOU PUT A PHOTOGRAPH ON THE CARD THEY THINK YOU ARE A PROSTITUTE. I AM NOT A PROSTITUTE. I DON'T DO PERSONAL SERVICES. I DON'T HAVE SEX WITH MY CLIENTS. BUT PUT A PHOTOGRAPH ON THE CARD, AND THAT'S WHAT THEY THINK YOU ARE. AND THEY DON'T READ. THE NUMBER OF CALLS I HAVE TO TAKE FROM TIME WASTERS WHO HAVE JUST NOT READ WHAT IS ON THE CARD, IRRITATES ME.

Despite many time wasters, Madam Shibari remains an advocate of cards as being the most effective method of advertising her profession.

Mistress Tempest, a well-established dominatrix and 'headmistress' working in NW1, is also a believer in the cards, and reflected on their production:

Mistress Simone printed both sides of her card, with tantalizing detail in the small print on the back

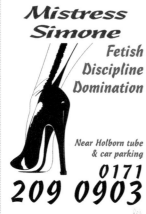

oys come from the cards'

WHEN I FIRST STARTED WORKING IT WAS THE MADAM OF THE HOUSE THAT ORGANISED THE CARDS FOR ALL THE GIRLS WHO WORKED FOR HER. SHE CHOSE THE IMAGES AND WROTE THE TEXT. THE MADAM RULED THE HOUSE AND YOU JUST HAD TO WORK WITH WHAT YOU WERE GIVEN. IT WAS MUCH STRICTER THEN. THERE ARE STILL SOME HOUSES THAT ARE RUN THAT WAY, BUT THE INFLUENCE OF THE MADAM IS NOT SO GREAT, THERE ARE ONLY A FEW HOUSES NOW THAT HAVE MADAMS. MOST GIRLS ARE INDEPENDENT AND ARE FREE TO DECIDE WHAT GOES ON THEIR OWN CARDS.

The majority of Mistress Tempest's clients are got through tart cards, although the amount of work coming that way is reducing. Cautious spending has pushed the sex industry into a recession, and 'unfair competition from Eastern European girls' has also had a detrimental impact. The competition between the 'girls-in-the-box' is strong and Mistress Tempest competes for business with girls working from another eighteen flats on her Georgian London Square, but as a dominatrix she has an advantage in the battle of the telephone box: the radius in which she can advertise is much greater than for other girls. Men seeking the services of a good dominatrix are

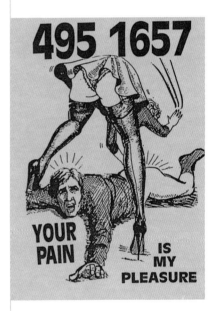

55

Miss Tempest prefers card

**CAGED
with a
CHAINED
REACTION
370
6914**

**THE MENACING WHISPER
IS MORE SINISTER
THAN A SHOUT
499 3290**

As soon as you put a
photograph on the card they
think you are a prostitute.
I am not a prostitute.'
– Madam Shibari

prepared to travel some distance; those that are looking for sex 'want it there and then on the doorstep'. The non-specialist can, therefore, only advertise locally.

Although Mistress Tempest has always worked by tart cards, and is dependent upon them for her work, she is disparaging of the current generation of cards, which are in her view 'cheap, tacky and too up-front'; they lack discretion. Mistress Tempest prefers cards that are typographic and not photographic, but feels pressurised into producing cards with images simply because 'that's what all the other girls do'. She has started to use the Internet; her graphic presence on the web is no different to that in the telephone box. However, experience has taught her that, 'you get a better sort of client off the Internet, one that is able to pay better rates'.

Goddess Grand Corbeau is an experienced dominatrix with four-and-a-half years professional experience both in the UK and America. She practices her 'Kraft of Domination' in London just minutes from the city centre. Goddess Grand Corbeau is a strict Mistress who provides clients with a particular and expert service; like most professional doms she does not offer sex, nor does she regard herself as a prostitute. As an apprentice dominatrix, Goddess Grand Corbeau was one of several girls working from a house run by 'Bernice' who:

OVERSAW THE PRINTING OF THE CARDS FOR ALL THE GIRLS WHO WORKED FOR HER. SHE SELECTED BOTH THE IMAGES AND THE TEXT, AND THERE WAS SPACE LEFT BLANK FOR US TO FILL-IN OUR OWN TELEPHONE NUMBERS OR WE WOULD PLACE TAPE OVER THE OLD NUMBERS

hat are typographic

AND WRITE THE NEW NUMBER ON THE TAPE. BERNICE WOULD GET 20,000 CARDS PRINTED IN ONE GO.

As a fully qualified dominatrix, Goddess Grand Corbeau worked from cards designed to her own specification. Rather than use photographs—'I am not very photogenic, and think it wrong to use photos that are not your own'— she chose to use caricature images taken from American pornographic comics, the images were of a 1940s style woman dominating and humiliating transvestites with her whip. As four cards could be got out of a printing sheet, four versions were made: one carried a list of services and the others displayed phrases such as 'you will work for me'. Goddess Grand Corbeau never used carders to distribute her publicity, rather she had a 'slave' to post the advertising between two and four o'clock in the afternoon: 'Clients would pick up the cards in their lunch hour or after work, but it would generally be the evening before they would call to make an appointment. Probably only one out of ten clients would actually make a booking'. However, it seems men do not read what is on the cards. Despite stating 'no personal services', many men would still ask the price of sex.

A SLAVE ONCE TOLD ME THAT MEN HAVE TWO HEADS, BUT THEY ARE INCAPABLE OF USING THEM SIMULTANEOUSLY. WHEN YOU HAVE BLOOD TRYING TO PUMP TO

57

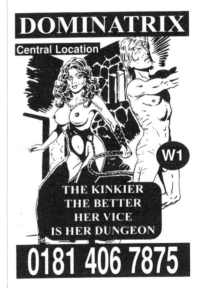

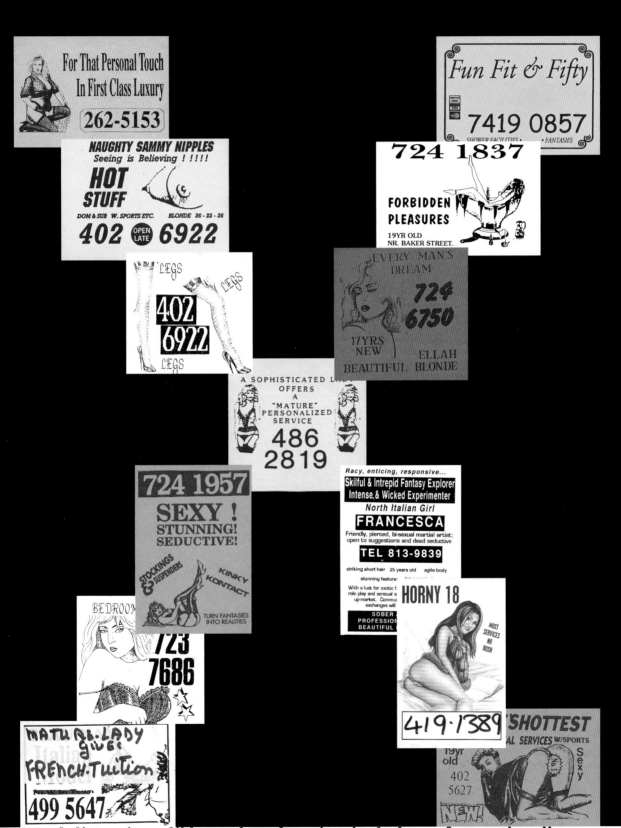

ome cards list an incredible number of services in the hope of attracting all comers; thers make no mention of any house specialty and merely publicise a name and a umber. Some girls claim to offer all sexual services. In reality, few are either willing r able to cater for all needs.

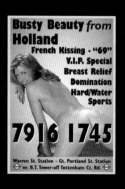

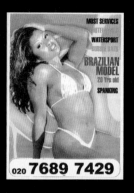

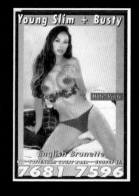

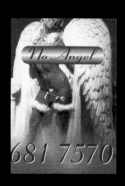

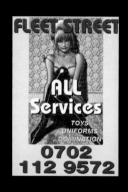

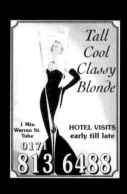

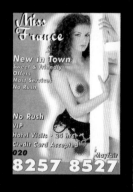

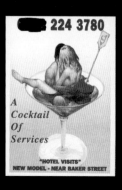

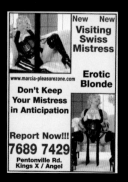

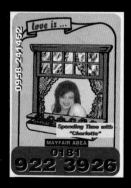

Every perversity can be found in a London telephone box and the cards cater for all. Some are very specific in what they offer; other, non-specialist providers, advertise either everything or nothing.

BOTH HEADS, GRAVITY WINS EACH TIME. MEN THINK AND ACT WITH THEIR DICKS AND THEREFORE DO NOT READ WHAT IS IN FRONT OF THEM. MOST MEN JUST SEEM TO PULL ANY CARD OUT OF THE PILE REGARDLESS OF THE SERVICES OFFERED, THEY ASSUME THAT ALL THE CARDS ARE ADVERTISING SEX.

In the marketplace, the distinction between prostitute and dominatrix is not always clear to clients. Goddess Grand Corbeau no longer works with cards; she ceased to use them after becoming exasperated with time wasters and irritated by men unable to read the advertising. She sees the cards as cheapening her work by associating her profession with prostitution, although she is quick to express her respect for that allied business.

Discontent with the cards prompted Goddess Grand Corbeau to the Internet: 'I have a rather expensive Internet site, but advertising on it is more of a waste of time than the cards. Anyone can access the Internet, regardless of age, and people don't read the blurb'. For Goddess Grand Corbeau magazines have proved to be the best way to advertise:

NOT EVERYONE CAN GO AND GET A MAGAZINE, YOU HAVE TO BE OVER 18, YOU HAVE TO KNOW WHAT YOU ARE AFTER, AND YOU CAN BE SEEN DOING IT. PEOPLE WHO COME TO ME ARE LOOKING FOR SPECIFIC THINGS; THEY TAKE TIME TO SEEK OUT THE MAGAZINES THAT CATER FOR THEIR PARTICULAR INTERESTS.

Magazine advertising is comparatively inexpensive when judged against the cost of tart cards. *Serious Mistress* will carry a full-page, full-colour advertisement with photos for £150 that will be seen throughout the UK and Europe.

Many of the girls that use cards do so because they have proved to be the most successful form of advertising for them. But how does the target audience feel about the cards?

61

There was a space left blank for us to fill in our own telephone numbers. – Goddess Grand Corbeau

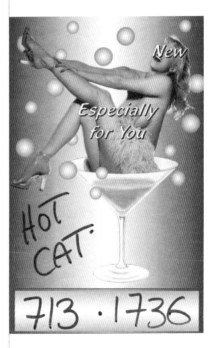

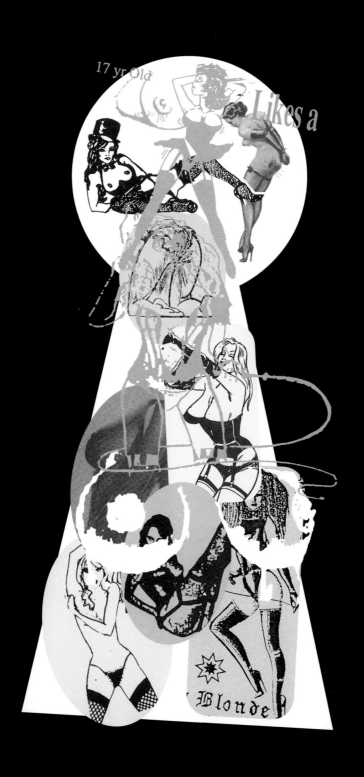

punters'

VIEW

LONDON IS A CITY FULL OF PUNTERS AND PARTYGOERS. According to the medical journal *The Lancet*, one in every eleven men in London pays for sex: they are neither sad old men nor inexperienced young boys, but are typically aged between 20 and 40 years old, often reputable, professional and articulate. Clients comprise the rich, famous, great and good as well as fathers, husbands, brothers and the boy next door. But with so many invitations to sexual nirvana posted in the call boxes, how do these prospective clients select a girl with whom to party?

First time visitors to London find its commercial sex scene difficult to negotiate. Not all clients are enthusiastic about street prostitution and the clip joints are expensive. Most visitors do not know to check out the classified sections of local newspapers (*East Ham Advertiser* or the *South London Mercury*); nor where to find the innumerable magazines (*Desire, Questa Contacts, Intimate Pursuits* or

TART
CARDS

Cards stating they are open till late impress customers as being more likely to have criminal or seedy associations.

Rendezvous) that carry small ads for saunas, massage parlours or escort agencies. Some resort to asking taxi drivers:

> I ENLISTED THE HELP OF THAT PATRON SAINT OF THE HORNY: THE CAB DRIVER. WE DROVE DOWN THE KINGS ROAD WHERE THE GIRLS WERE WORKING. THE CABBIE SUGGESTED HAVING THE GIRL DO HER BIT IN THE BACK OF

the underground nature o

> THE CAB, BUT THAT WAS A BIT TOO, ERM, 'EARTHY' FOR ME.

For the unfamiliar visitor, therefore, the only reasonable avenues open in London are the girls-in-the-box. Although most clients feel the cards are rather hit-or-miss, all agree that this uncertainty can add to the excitement. Each has his methods for negotiating the array of cards. But what induces a client to respond to one card and not another, especially when they all appear to be advertising the same product?

> I HAVE COME TO THE CONCLUSION THAT THE SAYING 'A MAN THINKS WITH HIS BALLS', IF YOU WILL FORGIVE THE TECHNICAL EXPRESSION, IS IN FACT ABSOLUTELY TRUE. IF THE MOOD IS UPON HIM, THEN IT SEEMS TO ME THAT DISCRETION IS LOST, AND THAT IN A TELEPHONE BOX (WHAT AN EXTRAORDINARY PLACE OF WORSHIP) HIS EYE WILL BE DRAWN FIRSTLY BY THE BEAUTY OF THE VENUS CONCERNED, THEN BY THE SORT OF SERVICE THAT IS BEING OFFERED — AND THAT THE UNLIKELIHOOD OF THE WOMAN LOOKING LIKE THE PHOTOGRAPH WILL BE PUT TO ONE SIDE. AND ONCE HE IS THERE, THEN THE RECEPTION HE GETS WILL DETERMINE WHAT HAPPENS NEXT.

Donald is an habitual, discerning and measured client

The nature of the advert, its hidden qualities, the double meanings and suggestiveness...

with specific requirements: he likes to be spanked. He requires special facilities and is only attracted to cards offering corporal punishment, a service that involves some skill in execution and for which he is prepared to travel. Donald reads the cards carefully, but will not act immediately, instead he files the name, number and range of services and keeps the infor-

...e process is all part of the excitement

mation until the time is right both emotionally and logistically to make an approach. Donald will be attracted to a particular girl if her services accord with his own needs, after that he is drawn by the image and although he realises the photograph is seldom genuine, it helps initiate his fantasy. Discovery of the card is followed by a telephone call. The tone and welcome that Donald receives from the maid will determine whether he will take his interest further. If he decides to proceed, then he enters into what he hopes will be a sustained relationship because his particular sexual predilection is dependent upon mutual trust that is developed over a period of time.

Not all clients bide their time, and not all are looking to give brand loyalty.

Ian is an experienced client with a penchant for masochism. He has visited prostitutes for over thirty years and fifty percent of his contacts come through cards in the telephone boxes. He never knows when the urge to visit a girl might descend, but when it does Ian acts immediately on instinct looking for cards that say 'local' because generally he 'wants sex there and then, I don't want to have to wait for it'. The adverts form a big part of his enjoyment: the ritual of going to a telephone box, reading the cards, and making the call contributes significantly to his pleasure:

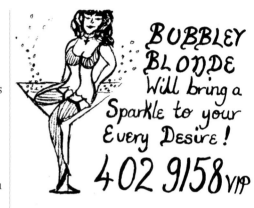

The process of searching and finding gives him his greatest thrill: and you never know what you are going to find.

65

corporal punishment gallery

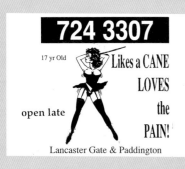

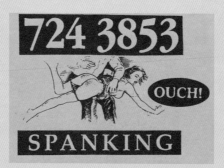

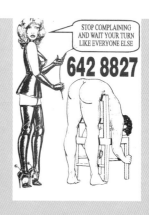

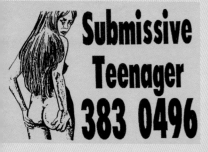

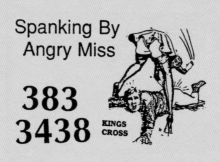

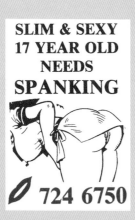

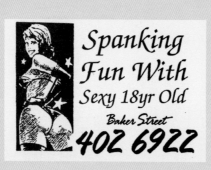

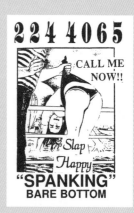

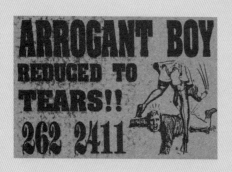

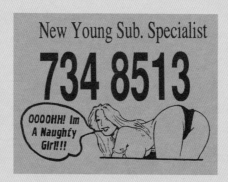

Nearly half of all London's tart cards offer some sort of corporal punishment (CP) with the participants and practitioners coming from all walks of life. For the true connoisseur of traditional English discipline and corrective punishment it is a serious and professional activity that takes much practice to perfect. Most of the CP

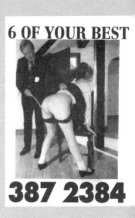
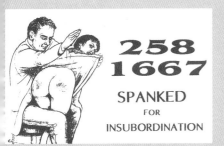
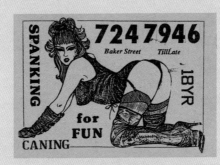
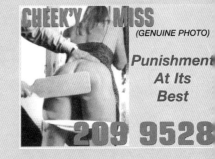
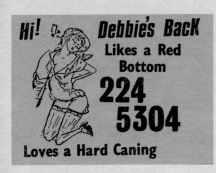
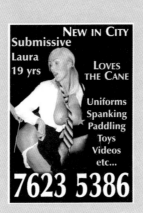
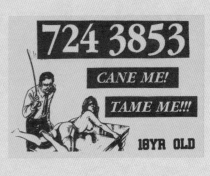
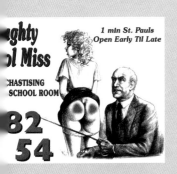
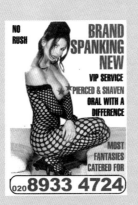
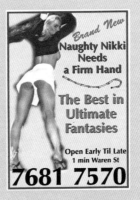
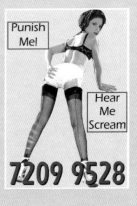
tart cards depend on humour to attract their clientele, and there are plenty of pert and glowing bottoms that attest to a girl's readiness to receive a beating, or whips and chains with which she will minister to her client.

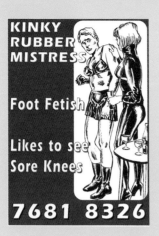
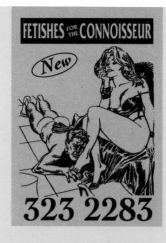
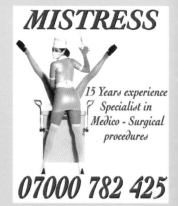
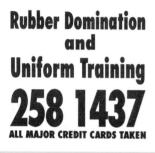
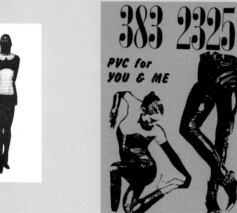

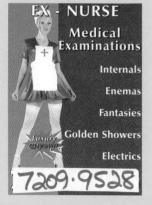
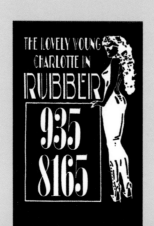
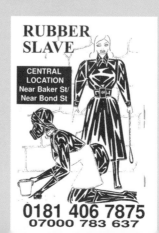
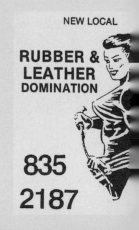

THE IMPROVISED NATURE OF THE PROSTITUTES' AD-
VERTS IS PART OF THE THRILL OF VISITING A GIRL.
THE NATURE OF THE ADVERT, ITS HIDDEN QUALITIES,
THE DOUBLE MEANINGS AND SUGGESTIVENESS, AND
THE UNDERGROUND NATURE OF THE PROCESS IS ALL
PART OF THE EXCITEMENT. THE CARDS IN THE TELE-
PHONE BOXES ARE EXCITING BECAUSE THE GIRLS ARE
PLACING THEM WITHOUT PERMISSION SO THE ILLE-
GALITY OF IT IS VERY EXHILARATING. HOWEVER,
THEIR OMNIPRESENCE REMOVES SOME OF THE ADVEN-
TURE. SO THE CARDS ARE DOUBLE-EDGED FOR ME.

After years of using the girls-in-the-box, Ian knows what
he is looking for: honesty. He never responds to the well-
produced cards with airbrushed images of glamour models
believing their polished veneer to be deceitful, and that a girl
who is dishonest with her advertising will be fraudulent with
her services: 'if she can't provide a genuine image of herself
then she won't provide a genuine service.'

THE PRESENT CARDS ARE OFFENSIVE AND AN INTRU-
SION AS THEY ARE FUNDAMENTALLY DISHONEST AND
INSULTING TO THE PROFESSIONAL SEX WORKER. IN
SOME WAYS THEY ARE DETRIMENTAL TO THE GIRLS AS
THE CARDS ARE TAKING CARE OF THE FANTASY ALREADY.
A GUY CAN LOOK AT THE PICTURE, PHONE THE GIRL,
AND IMAGINE THAT THE WOMAN HE IS SPEAKING TO IS
THE GIRL IN THE PHOTOGRAPH; HE NEED NOT TAKE
THE FANTASY ANY FURTHER.

Sincerity in advertising is important for Ian who is always
attracted to those girls that use an ordinary name rather than
an obviously fabricated nickname, and who publicise their
services with plain typography or handwritten notices. Ian is

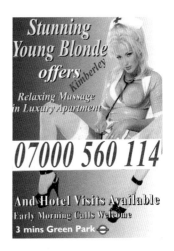

Overproduction suggests a
business that will only give
half-hearted service. – Jack

the illegality of it is very exhilarating... unce

seeking authenticity in a girl and it is the process of search-
ing and finding gives him his greatest thrill: and you never
know what you are going to find.

A good 'massage' is what Jack hopes to find from the tele-
phone box cards. Despite the proliferation of slickly produced
cards, Jack, like many other clients, is drawn to the simplest
and most rudimentary of cards. The less that appears on the
cards, the more likely he is to be drawn to the girl and her
services, preferring handwritten notices to printed ones,
straight information to slogans and rhymes. Jack always
avoids those with glossy photographs: 'their over-production
suggests a business behind the operation and that the girls
are 'house-girls' that will only give a half-hearted service'.
Like many clients, Jack looks to see if he can see a person
behind the cards and not an industry; the humanity of the
cards add to the enjoyment, the manufactured production line
suggested by the glossy cards reduces the experience.

In addition to any specialist services, most clients are seek-
ing girls that are individual, human and warm. They avoid cards
that provide a '24-hour' service or which state they are 'open
early till late' as this suggests agency involvement or that the
house is 'more likely to have criminal or seedy associations.'

As with all service industries, the girls-in-the-box provide

varying degrees of satisfaction: good, bad and indifferent. Occasionally, dialling a number can take clients to unforeseen and surprising places as one London journalist reported in 1994:

SEEMS LIKE THERE'S NO NOOK OR CRANNY, HOWEVER EXALTED, WHICH HAS NOT BEEN PENETRATED BY THIS

inty adds to the excitement

GRIM AND SPOOKY RECESSION. THERE AMONG THE LEGGY TEMPTRESSES AND 'NEW YOUNG BLONDES' IN THE HOLBORN PHONE BOX WAS A HAND WRITTEN CARD:

'LOOKING FOR A GOOD TIME?' IT SAID 'PHONE 071 930 4832' NATURALLY I RANG THE NUMBER.

'BUCKINGHAM PALACE' THE VOICE ON THE OTHER END SAID.

'I'M LOOKING FOR A GOOD TIME' I MURMURED.

'NOT HERE' THE VOICE SAID.

QUITE SO. FERGIE COULD HAVE TOLD US THAT. SO COULD PRINCESS DI. SO COULD PRINCE ANDREW. SO COULD . . . BUT WHY GO ON?

Most clients agree, when you pick out a card in a London phone box, you can never be quite sure of what you are going to get:

A LOT, PERHAPS MOST, OF THE GIRLS ARE INTERESTED IN QUICK TURN AROUND AND MAXIMUM MONEY. YOU'LL BE IN AND OUT AS QUICKLY AS THEY CAN MANAGE. THAT'S WHY IT'S REALLY GOOD TO FIND ONE WHO ISN'T LIKE THAT, AND WHO REALLY WANTS TO GIVE YOU A GOOD TIME SO YOU KEEP COMING BACK. ONCE YOU FIND SOMEONE LIKE THAT, IT'S WORTH KEEPING HER DETAILS, BECAUSE GIRLS LIKE THAT ARE A RARE TREASURE.

71

'Kimberly' employed the technique of printing 4 different cards, each with a different message; she uses descriptive text in these cards to entice customers.

design + production

Of the making and issuing of tart cards there is no end. Nor is there any limit to the ingenuity and doggedness of their creators who, despite elementary design knowledge and rudimentary production facilities, have unleashed in London a strong and evolving genus of vernacular street literature.

The people responsible for the design and assembly of the cards are various. Sometimes it is the girls themselves who determine their own publicity. In other instances the Madam of the house will have a supply of pre-prepared cards of her own design that are then allocated to the girls. For those girls trafficked to the UK from abroad, their cards will be provided by the men who brought them in to the country.

From the outset the resources available both to the prostitutes and their printers determined the design and manufacture of the cards. The whole production process was, of necessity, illicit; their makers only had access to a limited

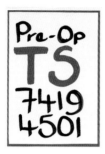

range of obsolete equipment and techniques and the fewer people involved in their manufacture the better. The early cards were the stuff of a kitchen table industry. More recently they have become products of an extensive, professional, well-organised and highly technical production process that, making full use of the inkjet, utilises technology that

Technology has considerab

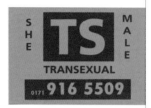

has considerably changed the appearance of the cards.

Getting words onto the cards has always tested their makers' resourcefulness.

'Lick and stick' – the process by which text is cut out, assembled and stuck together to form a single piece of artwork – was the norm in the early cards where text origination and design evolved simultaneously. The text was frequently put together using Letraset, (or other systems of dry-transfer lettering) that was rubbed down with varying degrees of expertise; the improvised and inexpert nature of their execution greatly added to the character and charm of the cards. Although produced in the 1980s, the early cards are distinctly 1950s both in tone and design and retain an old-fashioned charm. Many employ outdated types such as Brush, Chisel and Open Titling; or they use Baskerville and Garamond, two of the most pervasive text typefaces of the 1950s.

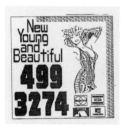

Getting words onto the cards has always tested their makers' resourcefulness.

Alternatively, the card makers would search out appropriate words or individual characters from magazines and newspapers or cannibalise rivals' cards for text. The words and letters were cut out and pasted down, but not always correctly: 'M' is often inverted to form a 'W' and the orientation of the 'S' frequently causes problems. The extraordinary and multifarious collection of typefaces and the gaucheness of their

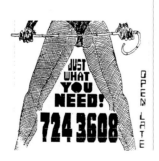

assembly add a welcome, human, and inviting quality to the cards that belies the services being advertised.

In the mid-1980s an increasing number of the cards were produced using word processing systems on which individual words or whole lines of type were composed, run off on low-quality bubble-jet printers and handed to the printer as origi-

...nanged the appearance of the cards

nal artwork. Many of these word processing systems used peculiar founts that became even more bizarre when system facilities allowed the user to artificially embolden, italicise and distort the type out of all recognition.

By the mid-1990s the majority of the cards were being 'typeset' on sophisticated personal computer systems. The advent of advanced and user-friendly technology that was within the financial reach of many resulted in cards that had a veneer of professionalism. The cards' makers made full use of all available current typefaces and added all sorts of effects: shadows, outlines, inlines, underscoring, and colour; type was compressed, expanded, rotated, reversed, flipped, runround and superimposed over images. Yet the arrival of PCs merely homogenised the cards: all used the same range of typefaces and the same graphic wizardry, and the typographic solutions became formulaic rather than individual. Humanity that characterised the earlier cards was lost.

For those with neither the patience to cut out lettering nor access to a computer, handwritten cards were, and continue to be, a cheap, cheerful and forthright option.

Whatever process was used to manufacture the text, some attempt was invariably made to select typefaces that reflect the specialised services that were offered and a typographic

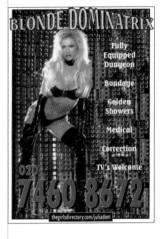

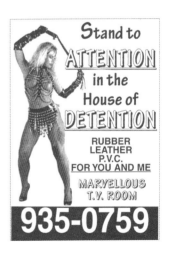

75

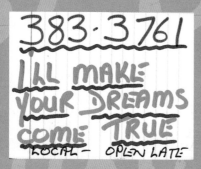

383·3761
I'll MAKE
YOUR DREAMS
COME TRUE
LOCAL — OPEN LATE

THE BEST
434 2624
TRY ME

Marco, Spanish
23, athletic,
active, 8½ inches
07900967124

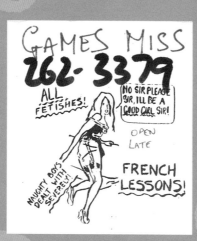

GAMES MISS
262-3379
ALL FETISHES!
NO SIR PLEASE SIR, I'LL BE A GOOD GIRL SIR!
OPEN LATE
NAUGHTY BOYS DEALT WITH SEVERELY!
FRENCH LESSONS!

MASSAGE
BLONDE
20 YRS
78284591

258·1930
SEX IN
BROWN
MISS

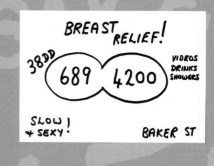

BREAST RELIEF!
38DD
689 4200
VIDEOS DRINKS SHOWERS
SLOW! & SEXY!
BAKER ST

For those with neither the patience to cut out lettering nor access to a computer, the improvised, handwritten cards are a cheap, cheerful and forthright option, which are very attractive to some men.

vocabulary evolved to reflect each specialist service. Cards offering schoolgirl facilities or *Le Vice Anglais* have a Victorian feel and accordingly use nineteenth-century typefaces; domination cards use stern words set in Gothic letters; and cards proffering massage need a luxurious and whimsical script.

Images are as important to tart cards as text. The first cards were invariably typographic but the girls quickly incorporated illustrations. Initially these were more suggestive of a

Printing tart cards has always been a backroom, backhanded job.

lady's hairdressing salon than a brothel but they inevitably became more risqué and evocative as the cards evolved. The early illustrations were usually monochrome line work and were cut out, traced or photocopied from magazines. Some of the images went through so many processes and were photocopied so many times that they deteriorated to an unacceptable degree and often bear the marks of having been inexpertly re-touched.

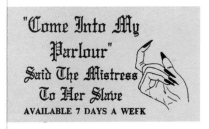

With charmingly naïve effect, some of the more artistically inclined producers attempted to illustrate their own cards. They were roughly and ingenuously drawn images but they created an instantly recognizable brand style for the girl and engendered a sense of humour and allure that was attractive to clients.

Cards dependent upon full-page, four-colour photographic images of nude, or nearly nude women were the norm by 1998. Cards carrying photographic images, despite claims to the contrary, are seldom of the girl offering the services; they are scanned from magazines or downloaded from the Internet.

77

fluorescent gallery

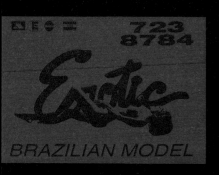

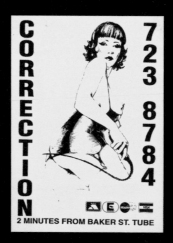

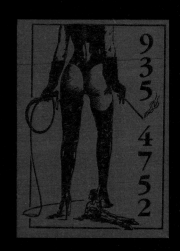

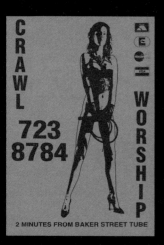

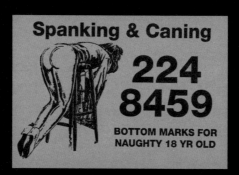

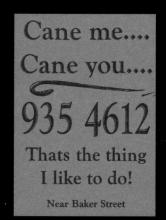

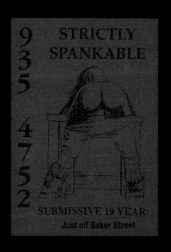

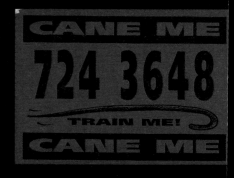

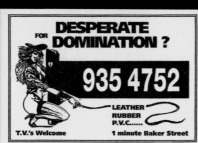

For those who sought visual superiority in the callbox card gallery, fluorescents did the trick. These luminous cards first surfaced in 1993, and for a short while central London phone boxes were the source of many a psychedelic headache.

Despite the superficial veneer and professionalism of these cards, closer inspection shows them to be as crudely produced as their 'lick and stick' forerunners. Inexpert use zof computer programs such as Adobe PhotoShop results in roughly cut-out images; clumsy retouching techniques leave the girls in the photographs looking curiously grubby; and the superimposition of censorship stars contribute a certain absurdity. Coarse screen values and highly visible moiré patterns add to the impression of cheapness. Charm and allure has been lost in the current cards and substituted with a standardized image of sexuality where all individuality and originality has been lost.

Printing tart cards has always been a backroom, backhanded job. There is an established circle of tart card printers recommended between the girls, but sometimes a new printer will make an approach for work. The printers work from unspecified and unknown addresses outside Central London – the further away from the centre the less likelihood there is of the printer arousing the curiosity of the authorities. Often the girls do not know the whereabouts of their printers who appear with the goods, disappear with the cash and only provide a mobile phone number. For those printers interested in earning quick money, tart cards can prove quite lucrative – provided they are prepared to take the risk and can move the goods quickly.

From the start, the majority of tart cards were printed on small offset litho presses. Occasionally letterpress was used to

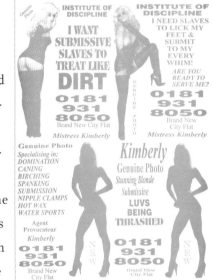

79

The early cards were the stuff of a kitche

print on cast-coated materials with super-glossy surfaces inappropriate for litho. The original cards were printed in black. Although the first four-colour card was produced in 1992 this was unusual and it was not until the summer of 1997 that four-colour cards began to appear and by the summer of 1998 they had become the norm. Not all the cards are printed; some are photocopied on decidedly substandard copiers with low toner, scratched drums or other defects that result in cards with unintentionally weird and wonderful effects.

Tart card printing has the advantage of enabling printers to use up odd stocks of paper that might otherwise become costly waste. Ream ends and off-cuts of awkward sizes are pricey to store; using them for tart cards not only rids the printer of an expensive problem but also allows them to make money as the paper is paid for twice – by the original customers and the girls.

Although the dimensions of the cards have changed over time, most are printed from an A4 sheet (8 1/4 x 11 3/4 inches) on small offset machines.

The first cards were small: A8 (2 x 2 7/8 inches). They were both discrete and businesslike and could be disguised among the other visiting cards filed in a man's top pocket. As more girls started to advertise in telephone boxes, some started to

'Pick-up' or clip art + hand retouching.

increase the sizes of their cards in order to catch the clients attention. When one girl increased her cards, the others followed suit and the cards were enlarged to A7 ($2^{7}/8$ x $4^{1}/8$ inches) or less frequently one-third A5 ($5^{7}/8$ x $8^{1}/4$ inches). The battle for attention in the phone box broke out again in the autumn of 1992 when a few girls increased their card sizes to

ble industry.

A6 ($4^{1}/8$ x $5^{7}/8$ inches) and fourteen months later, in January 1994 all the cards were A6 postcard size.

The enlargement of the cards to A6 coincided with the introduction of monochrome photographic images on the cards. At this stage the general orientation of the cards changed from landscape (which was convenient for text-dominated cards) to portrait, which was more satisfactory for cards that were increasingly dependent upon photographic images.

The modern cards are all printed on high-white paper suitable for four-colour images. The earlier cards were printed on multifariously coloured stock of whatever the printer had left over, but there was a definite preponderance of yellow. Black type on a yellow background gives particularly high visibility and allows a girl's card to stand out in a crowded telephone box. But for those who really sought visual pre-eminence in the tart card gallery, fluorescent cards did the trick. Fluorescent cards were all the rage in 1993: one girl started using them and the others followed suit.

Ironically, in the battle to get noticed it is not size, gloss, colour, fluorescence or saucy images that attracts the clients' attention. Rather it is the simplest of design solutions and the humblest of productions that capture the eye of the customer who in this world of sexual fantasy is looking for the honest voice in a sea of design subterfuge.

Tart card font selection –
an extraordinary and multifarious
collection of typefaces.

81

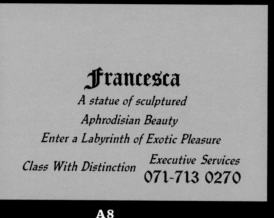

Francesca
A statue of sculptured
Aphrodisian Beauty
Enter a Labyrinth of Exotic Pleasure
Class With Distinction Executive Services
071-713 0270

A8

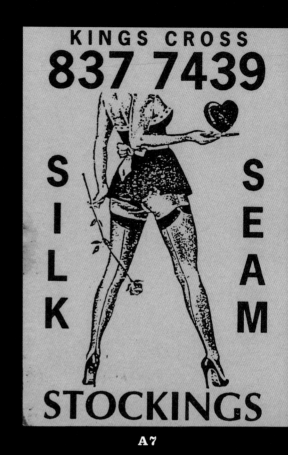

A7

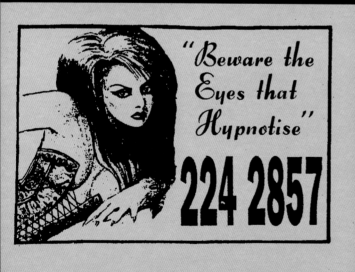

HOW THE CARDS ARE SIZED:

The International Standards
Organisation [ISO] paper
sizes are in three ranges:
A for general printing; B for
posters; and C for envelopes.
In the ISO A range, the basic
sheet A0, is 841 x 1189 mm.
Smaller sizes are derived
from A0 by progressively
halving but the significant
feature of the ISO range is
that the proportions remain
uniform i.e. 1:1.414.

The first tart cards, starting in about 1984, were small: **A8**. In the later 1980's, as
they began to appear in telephone boxes, the sizes of the cards increased to catch at-
tention, to **A7**, or less frequently one-third A5. In the autumn of 1992 a few girls in-
creased their card sizes to **A6** and fourteen months later, in January 1994 all the card

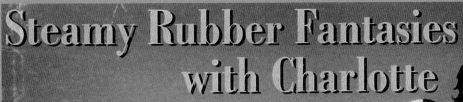

Steamy Rubber Fantasies with Charlotte
(Genuine Photo)

Hotel
Visits

...ry Mayfair House

...2 3925

A6

Emily Pretty 20yrs
Submissive & Uniform
Fantasy
Specialist

LUX +
Equipped
SW7

565 4790

THE ISO-A TRIMMED SIZES:

SIZE/MM		SIZE/INCHES
A0	841 x 1189	$33^{1}/_{8} \times 46^{3}/_{4}$
A1	594 x 841	$23^{3}/_{8} \times 33^{1}/_{8}$
A2	420 x 594	$16^{1}/_{2} \times 23^{3}/_{8}$
A3	297 x 420	$11^{3}/_{4} \times 16^{1}/_{2}$
A4	210 x 297	$8^{1}/_{4} \times 11^{3}/_{4}$
A5	148 x 210	$5^{7}/_{8} \times 8^{1}/_{4}$
A6	105 x 148	$4^{1}/_{8} \times 5^{7}/_{8}$
A7	74 x 105	$2^{7}/_{8} \times 4^{1}/_{8}$
A8	52 x 74	$2 \times 2^{7}/_{8}$

...re A6 postcard size. The modern cards are all printed on high-white paper suitable
...·four-colour images. The earlier cards were printed on various coloured stock-usu-
...y whatever the printer had left over. The cards on this spread are shown actual size.

42-24-36

CUM SPANK ME

SEYDER

ATTRACT & EXPER
VARDROP STRESS
NSFORE D TRAIN

TOP MARKS

Hard 9" For U

IS BOUND

language 9

S EX SELLS! But ironically sex is the one word that tart cards never use. Euphemisms, double entendres, catch phrases, rhymes and a specialised vocabulary are all drawn on to retail that most basic human instinct.

Like all effective outdoor advertising, tart cards use a persuasive vocabulary that makes the point quickly and is instantly understood: words and phrases are short, and there is no wasted language. The cards need to catch a client's attention, but they also have to be captivating and memorable because creating a 'brand image' is particularly important when everyone is offering the same product.

Brand image was most evident in the early cards, when typefaces, illustration and language all combined to give the girls a distinct identity. A prostitute may have moved around the city, but the visual and verbal tone of her cards followed her as did her clients. Much imagination went into the vocabulary of the early cards that frequently played on words or

introduced a twist to common phrases. Today's cards merely list the services provided and the art of creative copywriting has been lost to all but a few.

Tart cards make large promises, and when it comes to selling sex, size most definitely matters. Whether the girl is 'big and busty' or 'sweet and petite' it will be advertised; if she can boast a '44" DD', or has the 'best bum in W1' she will certainly publicise it. The boys are no different: a 'fully active 9 1/4" ' must be regarded as a temptation; and a feminine '34-26-34' transvestite with a 'rock hard 8-inches'

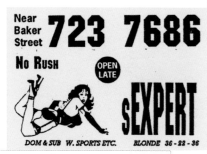

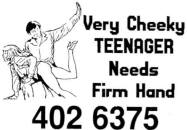

surely has the edge over her competitors. But this obsession with measurements sometimes produces curiosities like Lilly the 'sexy, leggy, black America lap dancer' recently advertised as just 6" tall.

The current girls-in-the-box often promote themselves by nationality. Many of them are trafficked illegally into the UK, and hiding behind the 'busty Dutch beauty', 'stunning blonde German' or 'Scandinavian model' there is probably an unhappy Ukrainian. 'Oriental' is the single largest ethnic group publicising its services: seldom Japanese, they are more often Thai working illegally in London on six-month tourist visas. Ethnic advertising engenders stereotypes: Australians are 'leggy, busty and blonde'; whilst Afro-Caribbeans add a little 'black magic' to any occasion; Italians are 'goddesses'; and Indians are 'Princesses' that will provide some 'hot spice'; Orientals are 'sweet dolls'; the English are 'roses'; and you can rely on the French for a little 'Ooh la la!'

Hair colour is another popular means of promotion. Blondes outnumber brunettes by two to one, and certainly seem to have more fun; they are 'playful', 'sexy', 'bubbly' and 'kinky' whilst brunettes make do with being 'tall' and 'sultry'.

But whatever the nationality or colour of the hair they are all, of course, 'models'! Many are 'new in town'; it is a phrase liked by clients as it implies an inexperienced girl providing a fresh service. As do the claims to have 'never been seen at just nineteen' or to be 'genuine 18'. 'Genuine' is the most over used word on tart cards; statements of authenticity in a world of make-believe are a necessary part of the game: photographs are alleged to be 'genuine' when they are obviously fabricated, and 'schoolgirls' are advertised as real when they are most certainly not. But it is all part of the mutual entertainment and conspiracy entered into by the girls and their clients. However, when a girl advertises herself as 'very discrete' in providing a 'no rush' service, her claims need to be real.

There are many specialist services offered on the tart cards. Just as each vice has its own typographic and visual language, so it has developed its own vocabulary. The British like to be spanked and punished. Forty-eight percent of the cards offer some form of corporal punishment or BDSM (Bondage, Domination and Sadomasochism) and rhymes and slogans have evolved to advertise these special vices. Corporal punishment rhymes could have come from *Carry On* films, as the girls invite clients to have a 'spanking good time' or tease them with 'bottom marks for a naughty 18 year old'. BDSM words, on the other hand, are more threatening and direct: 'I want submissive slaves to treat like dirt' and 'your pain is my pleasure.'

87

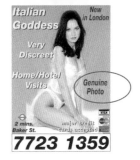

She's not only Italian, she's also genuine

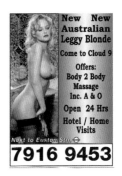

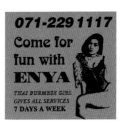

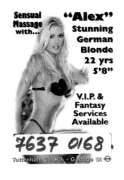

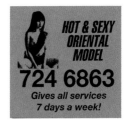

TART
CARDS

XMAS COMES
ONCE A YEAR
FORGET THE REST
THE BEST IS HERE
402 0183

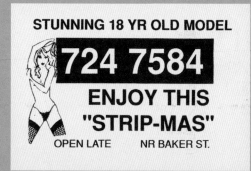

STUNNING 18 YR OLD MODEL

724 7584

ENJOY THIS
"STRIP-MAS"

OPEN LATE NR BAKER ST.

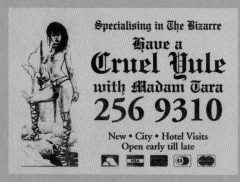

Specialising in The Bizarre
Have a
Cruel Yule
with Madam Tara
256 9310
New • City • Hotel Visits
Open early till late

HAVE YOUR SEATS
CANED FOR X'MAS

402 0183

LOCAL

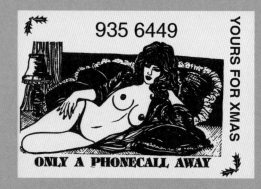

935 6449

YOURS FOR XMAS

ONLY A PHONECALL AWAY

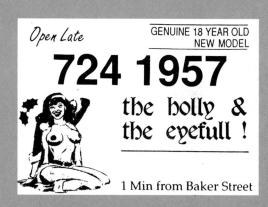

Open Late

GENUINE 18 YEAR OLD
NEW MODEL

724 1957

*the holly &
the eyefull !*

1 Min from Baker Street

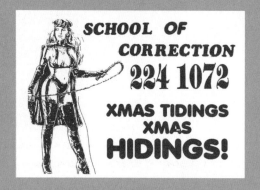

SCHOOL OF
CORRECTION
224 1072
XMAS TIDINGS
XMAS
HIDINGS!

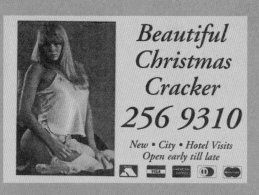

*Beautiful
Christmas
Cracker*
256 9310
New • City • Hotel Visits
Open early till late

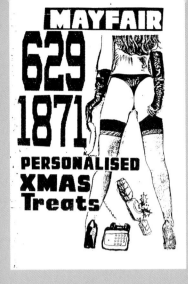

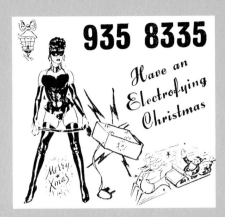

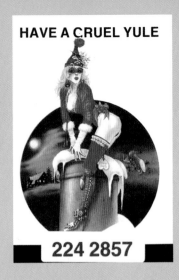

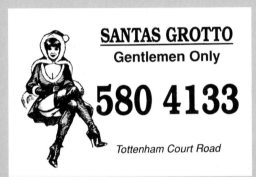

Tart cards often commemorate festive occasions: St Valentine's Day, Halloween, and the biggest festival of all, Christmas. The hand-drawn holly and ivy on some cards adds to the allure and charm of these very particular Christmas cards.

Sex is a funny activity

Tart cards have given rise to some very singular and creative copy writing. Euphemisms, catch phrases, rhymes and riddles have all been used to catch a client's attention and to create an appealing and unforgettable 'brand image' for each girl. Because all tart cards essentially retail the same product, many girls have been forced to become particularly inventive and persuasive with their vocabulary in order to sell their wares. Depending on the services offered, some of the writing is poetic, others menacing, but the best and most memorable tart card slogans are cheeky, witty and downright rude. But in addition to selling particular services, the copy writing is also used to commemorate festive occasions: St Valentine's Day, Halloween, and the biggest festival of all, Christmas. Special cards with distinctive illustrations and text are produced in order to entice clients to observe these special dates in the calendar with a visit to a girl-in-the-box; what better way to celebrate Christmas than by treating yourself to some 'Kinky Krismas Kapers' or a visit to a 'Stunning Christmas cracker waiting to be pulled'? The images that accompany the slogans are often as naïve and gauche as the words themselves, but all the hand-drawn holly and ivy merely add to the allure and charm of these very particular Christmas cards.

Sex is a funny activity, and there is much humour

and wit in the cards that frequently finds expression in brief lines of poetry from chirpy rhyming couplets:

> **New number new face**
> **Ring me now for the place!**

and the memorable:

> **If you're feeling rather randy**
> **Always keep this number handy!**

to blank verse adaptations:

> **Sticks and stones may break my bones**
> **But whips and chains excite me**

and altogether more menacing doggerels:

> **Stand over her body see her breast**
> **Hold the candle understand the rest?**

Often the girls will parody the phrases of popular adverts such as this re-working of a Heineken beer advertisement broadcast in the UK from 1975 onwards:

> **She's pretty she's young**
> **With skin like a peach**
> **She refreshes the parts**
> **Other girls cannot reach**

Films, too, are a source of inspiration: W2 has its own 'Pretty woman'; and London's 'Bondage Queen' is 'Every which way but loose'. James Bond has the single most influence on the cards with many girls claiming to be 'For your eyes only'. And more than one card makes a nod to the new computer technologies by proclaiming 'What you see is what you get' (wysiwig) – which is patently untrue.

Seasonal tart cards are produced to mark events like

TART CARDS

16

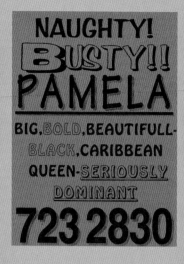

071-262 6588
Very Strict
Black Mistress

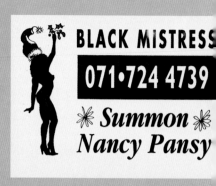

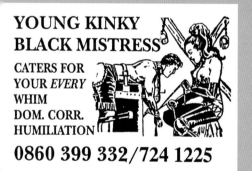

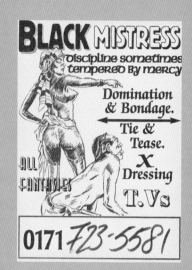

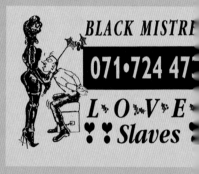

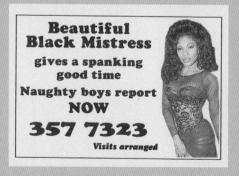

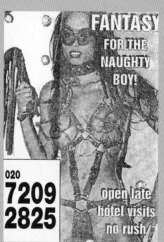

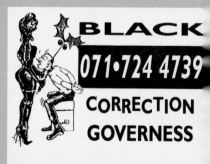

The current girls-in-the-box often promote themselves by nationality. Ethnic advertising engenders stereotypes: Afro-Caribbeans add a little 'black magic' to any occasion, though most in this collection are dommes ready to provide strict discipline.

Christmas, and amongst the hand-drawn holly and ivy there are equally festive words such as this parody of the nursery rhyme *Sing-a-song-of-sixpence*:

> **Sing a song of Christmas,**
> **a grotto full of toys,**
> **Lots of canes, whips and chains,**
> **for all you naughty boys.**

Or this playful rhyme:

> **Christmas cracker needs some fun!**
> **Come along and spank her bum!**

For those who prefer word-play to poetry there is a stream of one-liners: 'A treat yule love'; 'Red hot Xmas cracker'; 'Let me play with your jingle bells'; 'Good Queen Wence-lust, with the 42-inch bust'.

It is not just Christmas that is commemorated in the tart cards, what would Valentine's day be without:

> **Roses are red violets are blue**
> **St Valentine's coming and so may you!**

But probably one of the most effective, memorable and enjoyable slogans is the brief and forthright declaration:

> **'I like my job!'**

If advertising is the most fun that you can have with your clothes on, then the girls-in-the-box have certainly proved that to be true – and twenty years of tart card copywriting will attest.

93

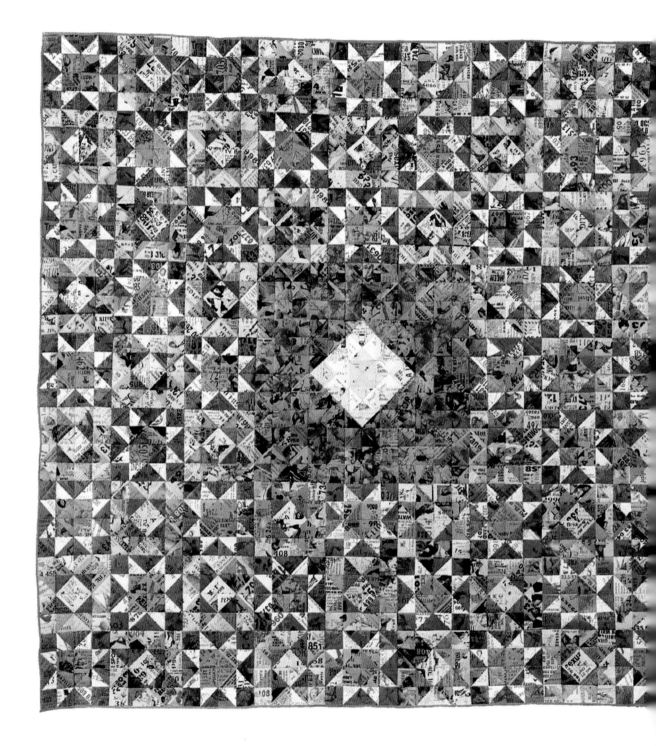

Tom Phillips' 'Women's Work' q

imitators & appreciators

THERE IS SOMETHING OF A CULT SURROUNDING TART CARDS. Once on the periphery of society, the cards have become inescapable and familiar elements of London culture and by their tenacity, pervasiveness and downright temerity have firmly ingrained themselves in London's, and the nation's collective awareness. Tart cards have a surprising cross-section of admirers, imitators and collectors – male and female, professional and amateur, establishment and anti-establishment – that have given the cards credibility coupled with a certain amount of subversive cachet.

No London-based TV drama is complete without a telephone box festooned with tart cards. In 2002, *Eastenders*, a BBC soap opera, broadcast a storyline involving prostitution and regularly showed the girls-in-the-box. The late-night comedy series *So Graham Norton* used a selection of the cards as a backdrop to its credits. Several spoof cards such as 'wear my socks' were featured in the offbeat BBC comedy series *The*

95

League of Gentlemen: the cards were based on originals that could be found in London in 2000. And during 2002 a TV commercial for adult and distance learning was broadcast centring on a card-bespattered call box.

Once on the fringes of design, the tart card is a genre that

Few of the **collectors** are **clients**

has begun to influence mainstream printed communication, and occasionally businesses have used the idea of the phone box card to promote their non-sex related services. In 1999, SyMark software developers (now trading as Pillar Solutions), produced a series of advertising cards for inclusion in a UK computer magazine. The card was undoubtedly inspired by London tart cards, its size, shape, typographic styling, layout, dominatrix image and carefully chosen vocabulary gave more than a passing nod to the girls-in-the-box.

The anti-establishment has also embraced the tart card genre. Nils and Ray Stevenson worked on the fringes of punk from its earliest inception; Nils became the Sex Pistols' tour manager, Ray their publicist and photographer. To promote the Sex Pistols' 1996 'Filthy Lucre Tour' Ray and Nils Stevenson produced four nihilistic 'prostitute cards' that carried photographic images of the band members and sexual slogans rendered in popular tart card typefaces. But unlike genuine tart cards, which are characterised by their warmth and humour, those produced for the Sex Pistols used harsh language and aggressive images that were designed to shock and repel rather than attract and persuade. The cards were stuck in phone boxes around London on the eve of the 100 Club press conference announcing the tour.

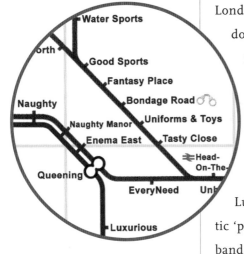

This map of the Underground is just a little unconventional – the tube stop names have been changed to reflect services of London tarts. 'Tart 'n Tube Map' by Phil Dynan available at the time of printing from the Tart Shop at www.phildynan.com.

The Space Hijackers are a group of Anarchitects set up in 1999 that have put the cards to subversive use. Space Hijackers oppose the hierarchy that is placed upon society by architects, planners and owners of space. Through the events they hold and the objects they produce they challenge the intrusion of institu-

d few of the clients are collectors

tions, corporations and urban planners into public space. In 2000 the Space Hijackers created a set of fake, but slickly produced, tart cards containing subliminal messages that they placed in phone boxes around the Charing Cross area of London.

Tom Phillips is someone who takes the cards very seriously. An artist, an associate of the Royal Academy and a Royal Academician in 1989, Phillips used thousands of tart cards in his creation of *Women's Work,* a patchwork quilt comprising small triangles of the single-coloured tart cards.

IN BRITISH HISTORY THERE IS A CONNECTION BETWEEN SEWING AND PROSTITUTION. IN THE VICTORIAN ERA THE SEAMSTRESS AUGMENTED HER EARNINGS BY SUCH MEANS AND THE PROSTITUTE GAINED A LITTLE EXTRA MONEY BETWEEN CLIENTS BY TAKING IN SEWING. THIS IS IN CONTRAST TO THE CLEAR OPPOSITION IN THE MALE IMAGINATION OF THE 'LITTLE WOMAN' AT HOME PLYING HER PATIENT NEEDLE AND THE POTENT OBJECT OF EROTIC DESIRE OFFERING OUTLANDISH SEXUAL ADVENTURES.

The quilt was first shown in the Royal Academy Summer exhibition of 1997 and the tart cards gained a worthy and reputable status.

As well as a role in high art, the cards have also been

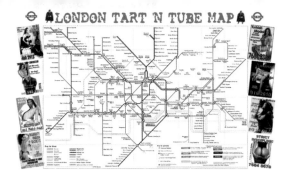

Tart cards have influenced mainstream

used for low games. Children have always loved collecting and swapping cards. It used to be Top Trumps, football, cigarette or Pokémon cards: nowadays it's tart cards. Children at some London primary schools invented their own version of the Pokémon card collecting craze using tart cards, taking the cards from the telephone boxes in order to collect and swap them. But it is not just children who play with the cards. There are a number of grown up web sites devoted to the playing of 'Prostitute Trading Trumps' or 'Pimp' both are free collectable card games where, if you are unable to collect your own cards, you can download recent selections from the web site, swap and play with friends.

There are various online escort agencies that advertise the tart card girls. Once a month 'Phone Box Escorts' collect cards from all over London and post them on their site. Rather than going out to a call box the prospective client can choose from the online card directory, pick up the phone, call and meet within the hour. A similar site is 'Cards in the Phone Booth' where clients can find links to card girls.

There are also, of course, the more academic collections of tart cards. In London, the Wellcome Library for the history and understanding of medicine has one of the worlds' greatest collections of books, manuscripts, pictures and

A now-defunct club called Mini Clubman used the tart format to promote themselves

(Opposite) The Space Hijackers created a set of fake tart cards containing messages that they placed in phone boxes around the Charing Cross area of London in 2000.

films around the meaning and history of medicine, from the earliest times to the present day. Within its walls, the library has a compilation of printed medical ephemera and a specialist collection of material relating to sexology. It is fitting, therefore, that the library has a remarkable and beautifully preserved set of several thousand tart cards spanning

rinted communication

the period September 1991 to present day. Also in London is the Guildhall Library, a major public reference library that specialises in the history of London, especially the City. As part of its interest in the history of London, the Guildhall Library has accumulated an interesting selection of tart cards. The Department of Typography & Graphic Communication at the University of Reading also has a collection of cards in its Centre for Ephemera Studies.

But it is not just large institutions that have amassed tart cards. There are also countless individuals who have collections large and small, selective or comprehensive. Few of the collectors are clients, and few clients are collectors. Their reasons for accumulating the cards are varied. Some were astute enough to realise this ephemeral manifestation of street literature needed preserving as a record of changing sexual and social practices; others collected as they enjoyed the visual and verbal wit of the cards; many others appreciated their artistic merit. For many the cards were an education that took them to a world that was often far removed from their own. Whatever their reasons for collecting, all became addicted to the practice and without exception warmed to the girls-in-the-box.

99

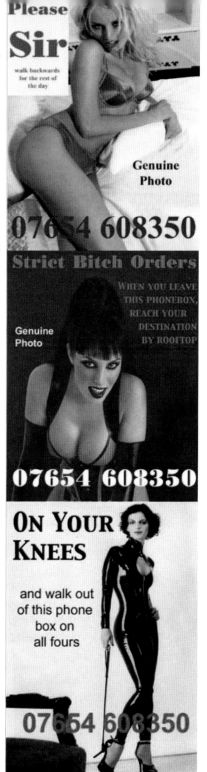

MODEL
UPSTAIRS

glossary

MOST INDUSTRIES HAVE DEVELOPED SPECIALISED vocabularies. These allow people from within a given trade to talk the same specific language, encourage mutual understanding and engender a sense of community. For those on the outside, specialist vocabularies can be both exclusive and baffling.

The sex industry is no different than any other business. It has built up its own language to describe experiences, needs, techniques, people and equipment. The terminology on the tart cards emerged because official English does not adequately cover the practices that needed describing, and those words it does have are inexact, moralistic or didactic.

This glossary is a compilation of technical terms and vernacular phrases that are commonly found on London's tart cards. The glossary has been divided in to eleven categories representing the main 'vices' on offer in the city.

101

TART
CARDS

A

A·NAL

Anal refers to all sexual or fetish practices involving the anus and/or rectum. Anal sex is a form of intercourse that has been explored by previous cultures and continues to be explored today. There are many clients who enjoy anal sex and statistics show that roughly 35% of heterosexuals and 50% of the gay community practice anal sex.

a-levels: the girl will allow the client to have anal intercourse with her. The term a-levels is a play on words. It comes from the set of examinations taken in the British education system at the age of eighteen that are known as 'a-level' or 'advanced level' examinations.

anal & oral: the girl will allow the client to have both anal and oral intercourse with her.

greek: a noun, adjective and verb for anal sex. The Greeks have a reputation for delighting in anal sex that originates from the ancient world where Greek women were intended for reproduction and Greek men were for pleasure.

strap-on: a dildo that has been attached to a jockstrap and strapped to the pelvis of a girl who will assume the active role with a client and perform anal sex on him.

B

BDSM

(bondage & discipline, domination & submission and sadism & masochism)

Bondage is the enjoyment of having bodily movement restricted for erotic reasons. It is a sexual practice offered by a significant number of girls who will tie up their clients with cords, ropes, silk scarves, collars, fetters, leg irons, handcuffs, or manacles, or through the use of stocks, pillories, cages, etc., so that the client can attain sexual gratification from

*relinquishing control. Discipline is a general term for all SM
activities other than physical restraint, especially
the ones that produce physical pain. Sadomasochism is a
combination of sadistic and masochistic sexual tendencies
within an individual. In sadomasochism the client
gains sexual gratification by alternatively or simultaneously
enduring pain and causing pain. Submission is
achieving sexual gratification by yielding control; following
orders, being restrained and kneeling.*

bondage bag: in some forms of specialised bondage the whole body, including the head, is encased in a bag, so that the client is completely immobilised and isolated from outside sensations. Holes are then sometimes made for access to the genitals.

cage: a large box or small room, possibly with bars, used for the confinement of a client. Cages are constructed to resemble prison cells, dog pounds, chicken coops, or coffins depending on the atmosphere to be created and the fantasy play to be enacted.

chains & canes: the girl will bind and restrain her client with chains and strike him with flexible canes, rods or rattan.

degradation: the process by which a girl erodes the pride, dignity, or self-respect of a client in order to establish her sexual power. She will usually do this through emotional and/or psychological means. Degradation is the psychological counterpart to physical pain. See also *humiliation.*

dungeon: a melodramatic term for a playroom, or a room that has been especially equipped for BDSM sex. See also *fully-equipped chambers.*

electros: services that include the use of electricity. Various devices can be applied to genitalia for sexual stimulation, or to other parts of the body to cause pain or pleasure. See also *shock-treatments.*

four-way suspension: a bondage technique wherein the client's weight is borne by restraints applied to the ankles and wrists. See also *suspension.*

fully-equipped chambers: a melodramatic term for a playroom, or a room that has been especially equipped for BDSM sex. See also *dungeon.*

gags and whips: a client's mouth will be stopped with a cloth, rope

or ball to prevent him crying out whilst being repeatedly hit with a flexible rod, length of rope or thin strip of leather attached to a handle or something similar; the client's sexual gratification is derived from pain, submission and humiliation.

hanging strap: an item of equipment used in advanced bondage practice to lift the body off the ground so that it hangs free in space.

hot wax: the practice of dripping hot candle wax on to a client's skin to produce pain or pleasure.

humiliation: the process by which a girl erodes the pride, dignity, or self-respect of a client in order to establish her sexual power. She will usually do this through emotional and/or psychological means. Humiliation is the psychological counterpart to physical pain. See also *degradation*.

medieval rack: an item of bondage furniture consisting of a horizontal platform or table with fixing points allowing someone to be stretched out on their back or front with easy access all round.

mummification: a specialised kind of bondage in which the whole body, including the head, is wrapped tightly using materials like clingfilm, gaffer tape, cloth or latex bandages until the client is completely immobilised. Holes are sometimes made for access to genitals and other areas.

nipple clamps: a gripping device that can be used to put pressure on the nipples.

shock treatments: services that include the use of electricity. Various devices can be applied to genitalia for sexual stimulation, or to other parts of the body to cause pain. See also *electros*.

sit sling: a cross between a swing and a hammock in which the client may be suspended.

strap down: the girl will physically control the movements of her clients by strapping or tying them down with manacles, ropes or chains.

strict massage: includes elements of bondage, humiliation and submission.

suspension: an advanced form of bondage in which the whole body is lifted off the ground and hangs free in space using harnesses and

suspension cuffs. See also *four-way suspension*.

tie & tease: refers to pleasurable sexual stimulation alternating with deliberate frustration administered whilst the client is restrained and powerless.

tools of the trade: any object used in BDSM activities.

torture: used to indicate the use of techniques that produce sustained sensations of continuously variable intensity, some of which may be painful.

two-way bondage: where either the client or the girl has their bodily movements restricted for erotic reasons.

C O R · P O · R A L P U N · I S H · M E N T

Variously known as English Discipline and Le Vice Anglais, *corporal punishment (CP) is a long time favourite pastime of the English.*
It is retributive sexual punishment involving the infliction of pain, often though not exclusively through blows administered with some form of flexible object like a whip or cane, or the palm of the hand.
In Britain it is sometimes used simply to describe the physical activities of caning and whipping without necessarily implying 'punishment'.

beating: the girl will strike her client who enjoys castigation as part of childhood punishment fantasies.

birching: a light bundle of twigs, traditionally made from the birch tree, that is used for striking the client.

blistering: some clients enjoy being beaten until the skin blisters.

caning: striking across the buttocks with a thin flexible rod, traditionally made of rattan or bamboo.

chastising: physically punishing or verbally scolding.

correction: physical or verbal punishment meant to improve or reform the person punished.

corrective massage: includes elements of corporal punishment.

cropping: punishment by being beaten with a riding whip.

flogging: a term used for striking a client's body with a variety of different flexible implements. It is sometimes used as a general term for these sorts of activities.

leathering: to whip with a leather strap.

paddles: flat instruments used for striking the body, particularly the buttocks.

slipper training: spanking the client's bottom with an old-fashioned gym shoe.

smacking: the girl will sharply strike her client, generally with the palm of her hand.

spanking: the girl will hit her client with the flat of her palm, typically on the buttocks.

strap: length of leather or other material used for striking the body.

tanning: to beat or flog.

traditional discipline: another expression for corporal punishment.

two-way spanking: spanking both administered to and received from the client.

D O M · I · N A · T I O N

In domination one person takes control of another's behaviour. This can be done as role play or humiliation and may be reinforced by the threat, or the actual implementation of painful physical activities or by restriction, bondage and physical control. A Dominatrix, Dommeor Femdom is a girl who takes on a sexually dominant role by physical, verbal or psychological means. A professional Dominatrix stages scenes where she dominates her male clients. Her work rarely involves genital sex. Some Dommes are renowned for their knowledge and skill at both the psychological and physical aspects of BDSM techniques.

body worship: the client is made to adore the girl's body and to lick, suck, and/or kiss her body or its individual parts.

boot licking: a practise used by a girl to dominate and humiliate

her clients; sometimes it is a means of indulging a fetish for boots.

discipline: refers to the girl imposing rules of behaviour in domination scenes and the 'punishments' used to enforce them. Discipline and punishment is usually physical, such as spanking or bondage but it can also be oral abuse.

maid training: some Dommes have maids who 'work' for them; maid training is the process of instructing a client in the Domme's preferences and conditioning the client's behaviour. It usually implies an element of cross-dressing. See also *slave training*.

punishment: physical, verbal, or psychological abuse of the client.

slave training: most Dommes have slaves who 'work' for them. Slave training is the process of instructing a client in the Domme's preferences and conditioning the client's behaviour. See also *maid training*.

FET·ISH

A fetish is an object to which powers are attributed that go beyond its natural ones; when the term is extended to sexuality, it indicates an object not naturally connected with sexual reproduction that nonetheless causes sexual arousal for some people. The best-known object fetishes are for items of clothing, especially those made out of particular materials like fur, leather and rubber, and boots and shoes.

foot fetish: the girl will offer clients the chance to kiss, lick, stroke, caress her feet for purposes of sexual gratification.

internals: intrusive medical examination performed as part of a medical role-play, involving the use of insertive medical equipment and procedures such as specula, douching and enemas. See also *medicals*.

kinky boots: the girl will offer clients the chance to kiss, lick, stroke, caress her boots for purposes of sexual gratification.

leather: probably the most popular fetish. Clients with a leather fetish may simply want to have conventional sex while they, or the girl (or both) are wearing leather, or they may enjoy leather in conjunction with other forms of BDSM.

medicals: typical medical scenes may involve intrusive physical examinations and insertive medical equipment and procedures such as specula, douching and enemas, and perhaps catheterisation, piercing, suturing, electricity, breath control with anaesthesia masks, and the use of naso-gastric tubes. See also *internals*.

medical room: a room equipped for performing some form of medical procedure or scenario. See also *white clinic*.

PVC: the girl will either dress herself in Polyvinyl Chloride for her client or the client may wish to be clothed in PVC by the girl.

rubber: after leather, rubber is the most popular fetish material. Most clients are interested in being clothed in hoods and bondage items made out of latex sheeting. Black is the most popular colour, and most of the clothing is purpose made. Some rubber clients want to be totally encased in rubber and inflated. Others wish to have the girls dressed in rubber.

satin & lace: a popular fetish. Clients with this fetish usually just want to have conventional sex while the girl is wearing clothes made from satin or lace.

stockings & garters: another popular fetish. Clients with this fetish usually just want to have conventional sex while the girl is wearing stockings and garters.

white clinic: a room equipped and dedicated to performing some form of medical procedure or scenario. See also *medical room*.

GEN·ER·AL

This category describes activities, objects and services that are not part of any specialisations.

all services: some girls claim to offer all the sexual services listed in this glossary. In reality, few are either willing or able to cater for all needs.

breast relief: the girl will stimulate the client using her breasts.

bubble bath: a bath filled with scented bubbles

that the girl will share with her client. She may also provide champagne, massage him with soap and provide hand relief.

escort: a girl who, for a fee, will escort clients to parties, restaurants or clubs and will also provide sexual services if requested. See also *private escort*.

executive services: a euphemism for sexual intercourse as distinct from a rubdown or masturbation. See also *full personal, personal services* and *VIP services*.

fantasy: an invitation to indulge the imagination and body, free of all sexual restrictions.

French kissing: to kiss with open mouths and probing tongues. In the wake of AIDS and HIV, not all girls are prepared to kiss their clients. If they are willing to French kiss, it is worth advertising.

fruit show: the girl will stimulate herself using a variety of fruits or vegetables.

full personal: a euphemism for sexual intercourse as distinct from a rub down or masturbation. See also *executive services*, *personal services* and *VIP services*.

intimate chat: the girl will 'talk dirty' to the client.

kissing: the girl will touch or caress all parts of the clients body with her lips.

personal services: a euphemism for sexual intercourse as distinct from a rub down or masturbation. See also *executive services*, *full personal* and *VIP services*.

private escort: is a girl who, for a fee, will escort clients to parties, restaurants or clubs and who will also provide sexual services if requested. See also *escort*.

solo shows: the girl will masturbate with the client watching.

striptease: the girl will slowly remove her clothing piece by piece to the accompaniment of music.

tease & please: the girl will playfully arouse sexual passion in her client and then refuse gratification. Eventually the client is allowed satisfaction.

toys: a generic term for any sexually-stimulating object used during masturbation, foreplay, or sexual intercourse.

videos: many girls have a supply of videos that clients can watch.

VIP services: a euphemism for sexual intercourse as distinct from a rub down or masturbation. See also *executive services*, *full personal* and *personal services*.

wrestling: a euphemism for the girl stimulating her client. It sometimes refers to two girls wrestling with each other in front of the client.

M A S · S A G E

Massage parlours are business establishments that specialise in body massages and, sometimes, saunas. Additional sexual services, such as relief massages (stimulation), dildo massaging, and enemas are available at extra cost. Some massage parlours are fronts for brothels.

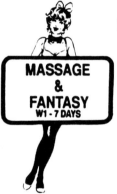

body-to-body: the girl will massage her client with her body.

massage: the girl will simply massage her client.

two-way body-to-body: the girl will massage her client with her body and vice versa.

VIP massage: massage with hand relief.

O · R A L

If oral sex is offered, the girl will use her lips, tongue, mouth or throat to sexually stimulate the client's genitals.

deep throat: oral sex performed by the girl on her client where she will take his penis to the back of her throat.

facial: the girl will perform oral sex on the penis with her mouth and allow the client to ejaculate over her face. It can also refer to the client masturbating over the girl's face to the point of orgasm.

French: any sex involving contact between mouth and genitalia. From the association of the French people with oral sex.

o-levels: oral sex. The term o-levels is a play on words. It comes

from the set examinations taken in the British education system at the age of sixteen that are known as 'o-levels' or 'ordinary level' examinations.

o-without: oral sex without the use of a condom.

reverse o/ sixty-nine (69)/ two-way: a position for mutual oral-genital sex.

ROLE PLAY

Role play is where both client and girl adopt different identities for the purpose of ang out a fantasy.

adult baby: refers to clients who gain satisfaction from dressing up in infants' clothing and using associated objects like pacifiers and cribs; may also indicate those who enjoy elaborate role-playing scenes in which they act out the part of a baby as fully as possible. See also *nanny* and *nursery services.*

gymslip training: an activity for TV clients. Clients enjoy dressing in gymslips and being treated as an adolescent girl.

nanny: a girl who will 'baby' an adult. She is a mummy (mommy) figure controlling an adult baby. See also *adult baby* and *nursery services.*

nursery services: where the girl will 'baby' an adult. She is a mummy (mommy) figure, controlling an adult baby. See also *adult baby* and *nanny.*

schoolgirl: a role play associated with corporal punishment. The girl will dress as a schoolgirl and will be spanked by the client. Alternatively, it is a TV activity and the client will be dressed as a schoolgirl and will receive punishment.

school medicals: a two-way role: the girl will submit herself to be medically examined by the client, or the client will present himself for examination by the girl.

schoolroom: a two-way BDSM punishment activity. A schoolroom is constructed in which client and girl play out the role of schoolmistress/ master and naughty boy/girl.

secretary: some clients enjoy seeing the girls dressed as secretaries, and then 'punish' the secretary for 'bad work'. Sometimes the tables are turned, and the secretary assumes power over her 'boss'.

uniforms: nurse, policewoman, prison warden, traffic warden are popular.

T O I · L E T

Some sexual activities make use of urine and faeces and some people get erotic pleasure from fetishising human waste. Sometimes these substances, or the process of excretion alone, can be enough to arouse sexual pleasure. On other occasions it can have overtones of role play or sadomasochism.

brown showers: scatological games. See also *hard sports*.

enemas: an anal douching by injecting a liquid, usually warm water, through the anus. Enemas are also used as play discipline or punishment.

golden showers: another phrase for urophilia and urolagnia, the terms used for people with a sexual fascination or fetish for urine and urination. See also *showers, watersports*.

hard sports: scatological games.

nappies (diapers): this refers to the client wishing to be put in to a nappy that they may then soil. Often used as part of adult baby role play. See also *adult baby, nanny* and *nursery services*.

showers: another phrase for urophilia and urolagnia, the terms used for people with a sexual fascination or fetish for urine and urination. If a girl offers golden showers she is willing to urinate over, or be urinated upon by her client. See also *golden showers*, and *watersports*

splashing: semen and urine and other fluids secreted at orgasm.

toilet services: the giving and receiving of golden showers and/or brown showers, urinating and/or defecating on a partner as a form of slave training.

two-way watersports: a girl is willing to both urinate over, and be urinated upon by her client.

watersports: another phrase for urophilia and urolagnia, the terms used for people with a sexual fascination or fetishism for urine and urination. If a girl offers golden showers she is willing to urinate over, or be urinated upon by her client. See also *golden showers, showers.*

T V / T S

Transvestites [TV] seek sexual pleasure from wearing clothes that are normally associated with the opposite sex. They are not necessarily homosexual. A transsexual [TS] is someone who feels uncomfortable with their biological sex and feels that they are really of the opposite sex. Some transsexuals take hormones or have surgery to make their bodies like their sex of preference. A pre-op transsexual is someone whose genitals have not yet been surgically altered.

cross-dressing: a girl will dress a client in clothing usually worn by the opposite sex. Cross-dressing can be carried out as a sexual thrill in itself. See also *x-dressing.*

deportment: a client will receive instruction in how to stand, sit or move like a woman.

feminisation: a client will be taught how to walk, dress, speak, arrange the hair and apply make-up in the manner of a woman.

transformation: a client will take on all apparent attributes of a woman.

tv salon: a hair and beauty salon where a man can have make-up applied and hair dressed so that he appears as a woman.

wardrobe: contains all the necessary clothes for a man to take on the appearance of a woman

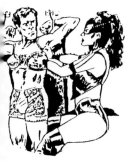

x-dressing: a girl will dress a client in clothing usually worn by the opposite sex. Cross-dressing can be carried out as a sexual thrill in itself. See also *cross-dressing.*

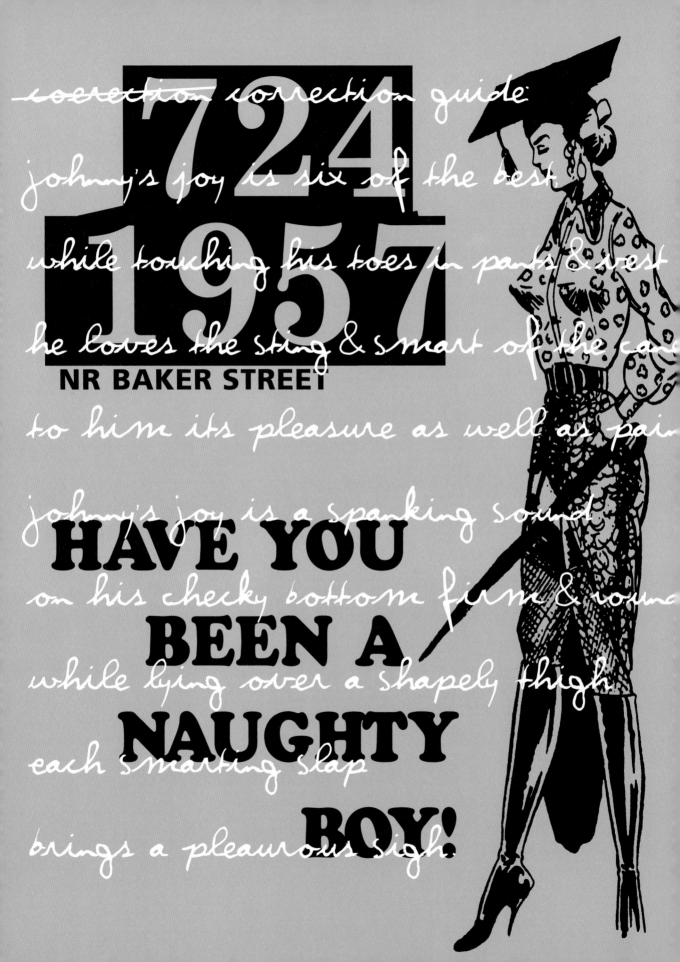

ACKROYD Peter; *London: the biography*; London: Vintage; 2002

BAILEY, Paul: *An English madam: the story of Madam Cyn, Queen of the scandalous luncheon voucher parties*; Glasgow: William Collins and Sons, Ltd; 1987

BINDMAN Jo; 'Redefining Prostitution as Sex Work on the International Agenda'; Anti-Salvery International, 1997

BRACCHI, Paul; 'Nasty Card Tricks of the Call-girls'; Brighton: *Evening Argus*; 16 September, 1992

CALIFIA, Patrick; *Sensuous Magic: a guide to SM for adventurous couples*; San Franscisco: Cleis Press Inc., 2001

CHARLES, Alice; 'Smart tarts, stupid men'; London: *Ms London*; 1 July 2002

CLAMEN, Jenn; 'Sex in the City'; London: *The Guardian*; 9 July 2002

ECKERSLEY, Jill; 'Going Bonkers'; London: *Girl About Town Magazine*, September 25, 2000

FISHER, Trevor; *Prostitution and the Victorians*; Stroud: Sutton Publishing Limited; 1997

HAYNES, Alan; *Sex in Elizabethan England*; Stroud: Sutton Publishing Limited; 1997

HELLER, Steven [ed]; *Sex Appeal: the art of allure in graphic and advertising design*; New York: Allworth Press; 2000

HIGHSMITH, Cyrus; 'I'm wet and ready now: a brief look in to the world of adult typography'; *Sex Appeal: the art of allure in graphic and advertising design*; New York: Allworth Press; 2000

JEWELL, Patrick; *Vice Art: an anthology of London's prostitute cards*; Harrogate: Broadwater House; 1993

JONES, Derek [ed]; *Censorship: a world encyclopedia*; London & Chicago: Fitzroy Dearborn Publishers; 2001

MacERLEAN, Neasa; 'Sexual Union'; London: *The Observer*; 28 July 2002

MAHEW, Henry; *London Labour and the London Poor: a cyclopaedia of the condition and earnings of those that will not work, those that cannot work, and those that will work*; London: Charles Griffin & Co; 1861

MILLER, Philip and DEVON Molly; *Screw the Roses, Send me the Thorns: the romance and sexual sorcery of sadomasochism*; Connecticut: Mystic Rose Books, 2002

NORTH Maurice; *The outer fringe of sex: a study in sexual fetishism*; London: Odyssey Press, 1970

PAXMAN, Jeremy; *The English: a portrait of a people*; London: Penguin Books; 1999

PHILLIPS, Tom; 'Tart Art: the graphic language of prostitute cards'; London: *Eye 34*; 1999

'Phone Sex'; Brighton: *The Brighton Source*; October 1998

SALGĀDO, Gāmini; *The Elizabethan Underworld*; London: Sutton Publishing; 1977

TURNER, Roy; *You beat people up for a living don't you mummy?*; Brighton: Absolute Elsewhere, 2001

WORTHINGTON, Michael; 'Sex and typography revisited: letter of discredit'; *Sex Appeal: the art of allure in graphic and advertising design*; New York: Allworth Press; 2000

WWW.WHATSYOURS.COM: Everybody has a fetish – whatsyours? An online magazine covering the expanding culture of fetish. An excellent resource, it acts as a bridge for newcomers into the fetish scene and everyone interested in the subject.

The X Directory: Kinky cards 1984-1994; London: Pi34 Publishing; 1993

the end

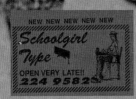
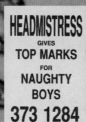
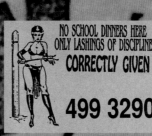
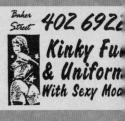
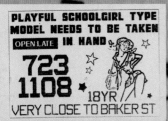
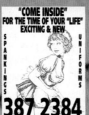

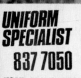
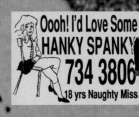
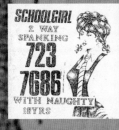
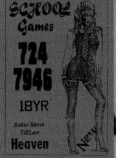
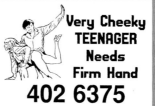

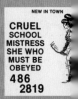
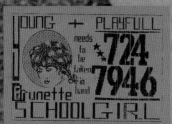

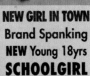